A Countryside Can

The photography of Roger Redfern

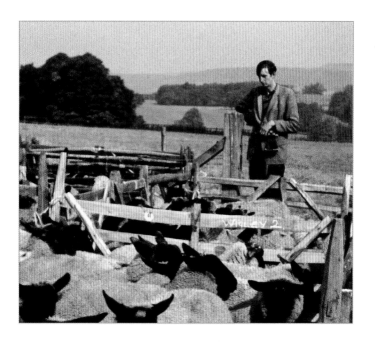

Christopher Nicholson

Published by
Whittles Publishing,
Dunbeath,
Caithness, KW6 6EG,
Scotland, UK
www.whittlespublishing.com

ISBN 978-184995-101-2

Printed by Finidr. The Czech republic.

Typesetting by Raspberry Creative Type, Edinburgh

Front cover: Tamworth piglets enjoying an afternoon nap in May 1996 (Roger Redfern)
Title page: Roger Redfern at the Edensor Sheep Sales in September 1970 (Author)

CONTENTS

Introduction	3
A Countryman's Eye	8
Peakland Days	13
Over Hill and Dale	35
In Field and Forest	54
Portraits	65
A Weather Eye	73
Days Gone By	81
The Changing Seasons	90

INTRODUCTION

Roger Andrew Redfern's sudden death was a shock to countless readers of his books, magazine articles and newspaper columns about the countryside, its traditions, wildlife, and landscapes. His writings about his travels and exploration of different areas of Britain and abroad spanned 50 years until his passing, aged 76, in November 2011.

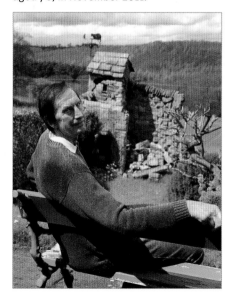

In his garden at Old Brampton, 2009 (Photo: Author)

Most notably he was a regular contributor to *The Guardian* newspaper's *Country Diary* feature for over 28 years, writing over 700 entries, but he had also contributed articles to virtually all of the UK's countryside and outdoor interest magazines, and a great many other mainstream titles. He is the author of over 30 books about walking and living in the British countryside.

His writings are often described as lyrical or poetic because of his mastery of being able to choose exactly the right descriptive and flowing prose for every subject that inspired him to take up his pen. In one of his obituaries he was described as 'the doyen of Peak District outdoor writers'. His prolific output places him as one of the truly remarkable writers about British countryside matters, particularly in the Peak District of which it is said that there wasn't a single summit from Cheshire to Lincolnshire he hadn't set foot on.

However, what most of his loyal followers will be unaware of is that he was also an exceptional photographer, recording his travels and experiences for as long as he had been writing about them. He used mostly colour slide film, at first Kodachrome – the benchmark for image quality, followed by Fujichrome – its natural successor, and in his later years he even embraced digital photography. But his images have never received the same recognition as his prose, even though they were composed with the same sensitive skill and creativity. Most of them remained unpublished in his lifetime. This book will give some of them their first appearance in print, and others – in the process of selection – possibly their first exposure to daylight since they were returned from processing and viewed for the only time. First, a little background about their creator.

Roger Redfern was born in Chesterfield in November 1934, the son of Arthur Lewin Redfern, an engineer's draughtsman, and his wife, Rachel. His great uncle was Arnold Muir Wilson, a Sheffield lawyer, pioneer motorist, explorer and mountaineer. Arnold's daughter, Florence Roma Muir Wilson, achieved acclaim as a novelist using the pen name of 'Romer' Wilson in the years following the First World War.

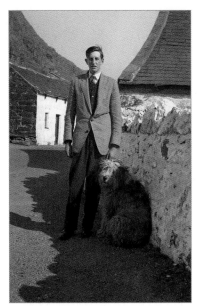

Roger in 1955 at the top of Llanberis Pass with his dog, Ferguson.

He was brought up in Dronfield, a small industrial town midway between Sheffield and Chesterfield before a move, after his father's death, to the leafy suburbs of Chesterfield at Old Brampton which gave almost instant access to his beloved Peak District. It was in these early years at Dronfield and visits to his aunt's farm above the Mawddach Estuary in Wales that his love of the countryside and its way of life undoubtedly began.

His father was a major influence – in *Peakland Days* (1970) he writes, *Though a notable engineer and technician, A.L.R. was most at home in garden, wood and on the high hills for he was at heart a real countryman.* Exactly the same sentiments could be used to describe Roger.

He went to Dronfield Grammar School between 1945–49, a school he was later to return to as a teacher, then a couple of years working on a farm in Unthank that actually straddled the boundary of the newly-born Peak District National Park. Between 1952–53 he studied at Broomfield Hall, Derbyshire's College of Agriculture where he was awarded a National Certificate of Agriculture. This was followed by a one-year teaching course at Worcester College of Education that gained him a Certificate of Education. His first teaching post is thought to have been in the Saddleworth area of what is now Greater Manchester, and from where he moved closer to home at The Gosforth School in Dronfield Woodhouse in the late 1950s.

At the same time, Roger began to write about his love of the countryside for magazines, newspapers and in books. Perhaps his years at a house in Dronfield's High Street that was allegedly once owned by Byron had some influence? If not, his regular visits to his aunt's farm above the Mawddach estuary in mid-Wales for the long summer holidays almost certainly did.

His first books were a *Rambles in . . .* series for Robert Hale starting in 1965 with *Rambles in Peakland*, followed by companion volumes for North Wales and the Hebrides. Then more books for the same publisher on Pennine themes; *Portrait of the Pennines* (1969), *Peakland Days* (1970) and *South Pennine Country* (1979). Subsequent volumes covered a most diverse range of topics and areas; *Gatehouses of North Wales, The Dukeries of Nottinghamshire, Walking in England, Dronfield in Old Photographs* and *A Snowdonia Country Diary.*

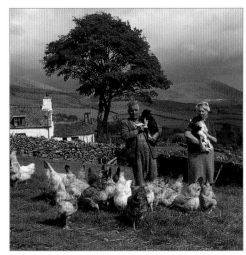

Aunty Mary and Uncle Hughie at Llwyn-onn Bach, their hill farm above the Mawddach in mid-Wales in 1965.

Proper climbing was another love, a skill he honed on exposed gritstone edges, Welsh crags and Alpine peaks which led to him becoming the editor of *Mountain Craft* magazine (now called *Mountain*) during the mid 1960s when contemporaries like Joe Brown used to contribute. He had a keen interest in the geology of the mountains he walked in, and often wrote about how the features were formed and looked. In April 1960 he was elected a Fellow of the Royal Geographical Society because of *his contributions, many of a geological nature, to mountaineering literature.*

In 1958 he walked the Appalachian range along the eastern seaboard of North America, followed a year later by his first visit to the Valais Alps of Switzerland. By 1961, at just 27, he led the British Expedition to Ruwenzori – 'The Mountains of the Moon' – on the border between Uganda and the Democratic Republic of Congo. The Alps were a frequent repeat destination right up to his death, one trip in 1966 involving an almost successful ascent of the Matterhorn.

Back in Dronfield, he returned in 1967 to his *alma mater*, now called Henry Fanshawe School after its founder, as a teacher of biology, geography, rural studies and general studies, a post he held until retirement. At the same time, from 1963 to 1973, he was busy writing regular pieces for the *Yorkshire Post*'s Country & Coast feature as well as articles for all the major countryside magazines such as *Country Life, The Dalesman, High, The Countryman, Derbyshire Life and Countryside, The Great Outdoors, The Peak District Magazine* and also occasional pieces that he felt would be of greater interest to the readership of *The Lady* and *The People's Friend*.

1988 saw the birth of his own self-publishing venture, Cottage Press, that produced a range of titles covering the history, notable buildings, walks, and old photographs from the towns, villages and countryside between Chesterfield and Sheffield. It was a winning formula – an interesting, quirky or historic photo accompanied by an extended caption or explanatory text. Read these splendid little volumes and you will learn much about the early life of Roger Redfern and his love of, and views about, the countryside of north Derbyshire.

At the time of his death he was working on another series of walking guides covering Snowdonia and the Malverns that also featured his talents as a photographer, and if that wasn't enough for a 76-year-old to have on his plate, he was also exploring the possibilities of online e-books of his work. In January 2012, two months after his death, Guardian Books published *Peak Passions: A Country Diary* – but only in a format that had to be downloaded and read on a hand-held electronic reader. Alas, he never saw his work about past traditions and bygone days published on cutting edge technology.

His interest in photography must have begun at the same time as he started writing for newspapers and magazines. His earliest colour slides date from about 1958 and from then onwards it seems that his camera was used to record his travels as much as his pen. This resulted in a body of work of many thousands of colour and black and white photographs – a magical and nostalgic collection of the weather,

A few of the Cottage Press books Roger produced from 1988 onwards.

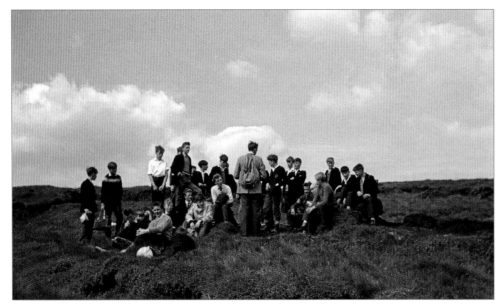

Surrounded by his pupils high in the Peak District in 1962, on one of the hundreds of field trips Roger led for pupils of Gosforth and Henry Fanshawe Schools during his career.

cry of 'Mister, stop this car immediately!' was barked as Hector had spotted an opportunity for a once-in-a-lifetime photograph of a sunset, cloudscape, a group of animals in exactly the right composition, a train on a viaduct, a derelict building, or just people doing something interesting. One of his books, *Peak District Memories* (1997), was illustrated entirely with Hector's photographs.

An intensely modest and self-effacing man, it has taken years of conversations to discover his many and varied talents. But it was time well spent, because my questions also unlocked his dry sense of humour. He had a story about virtually everything and everyone he'd encountered on his travels, which he retold with enthusiastic mimicry and a wry smile. A lot of his humorous anecdotes also found their way into his books and newspaper columns.

He was interested in people, particularly country folk, and could spend hours just asking questions so that he understood more about their way of life. His dry humour and the incredulous stories he could tell made many a walk through the sodden peat gulleys of Kinder Scout and Bleaklow pass almost unnoticed.

It's been a difficult, yet fascinating, task to try and choose the photographs for this book. Because of their age some of them can rightly be

flora, fauna, people and the places he'd seen in almost six decades of photography.

A flair for composition seems to have been a natural gift, no doubt helped by his interest in pen and ink drawings where perspective, composition and flow were transferable skills into his photographs.

He always spoke with great affection and admiration of the skills of a teaching colleague he worked with – E. Hector Kyme – another self-taught photographer whose darkroom wizardry Roger held in great regard. EHK contributed many black and white images to Roger's books and often accompanied him on his trips into Peakland, the Yorkshire Dales, Scotland and North Wales specifically to take photographs for his latest work in the days when the only colour photograph was on the cover. I was told stories of driving through some rural location with EHK beside him, when without warning a

regarded as valuable documents of social history, recording as they do scenes from a bygone era. But how do you pick one image over another when you have thousands to choose from? It's been a difficult choice, based on knowing the man and knowing the kind of images that he would have been pleased to see in print, which will also hopefully appeal to a wider audience. Would he have picked the same images as me? We'll never know, but I'd like to think that there'll be quite a few of his favourites amongst these pages. So please enjoy this book as a small record of the work of Roger Redfern, the photographer, whose images will surely enthral and delight in the same way as his writing.

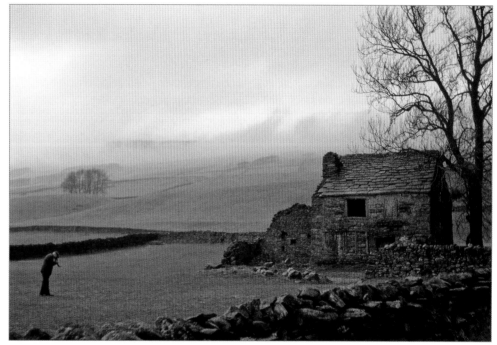

This is E. Hector Kyme at work – photographed by Roger staring into the top of his twin-lens Rolleiflex camera while photographing a derelict barn in Wensleydale, Yorkshire in April 1968.

Author's note: For the purpose of this book I've given the heights of all the various hills and mountains that are mentioned in the text in feet. This was the measurement that Roger used in all his writings, although sometimes a publisher would add the metric equivalent in brackets. He never did!

A COUNTRYMAN'S EYE

Over the 76 years of his lifetime, Roger Redfern covered thousands of miles on foot and thousands of feet of altitude – the equivalent, he thought, of many ascents of Everest – walking the hills and countryside of England, Wales and Scotland. A true countryman, he liked nothing better than exploring the hidden corners, rural backwaters and dramatic landscapes of the British countryside.

This volume of his photographs concentrates not on the craggy mountain peaks of Snowdonia, the north-west Highlands of Scotland, the northern Pennine summits, Lake District fells or south Wales beacons because they willl be covered in *A Mountain Camera*, a companion volume.

Here we're on lower slopes where fields of grazing animals or growing crops are enclosed within ancient hedges or dry-stone walls, where villages and towns retain a unique character and original buildings, and streams and rivers meander through unspoilt countryside. It's the countryside he walked as a small boy, right up to a few days before his death when he was taken ill while walking in the Staffordshire moorlands.

The same countryside that today requires no more than the right clothing, a good map and a compass to explore in the same way that he did.

In that countryside he ranged far and wide across rural Britain from Dorset and Essex in the south to Cape Wrath in the north – and virtually all points rural in between. He was never happier than just wandering around in the very best scenery that the British countryside could offer, stopping to talk with villagers or farmers he met, or sampling the refreshments at the huge number of tearooms he discovered the length and breadth of the country!

He empathised with the rural way of life because that was his own way of life. He understood the changing seasons and the beauty of each because he had been a farm worker and watched them slip by and recorded them with his camera. And he was fascinated with the weather, the drama it could bring and the problems it could cause. Some of his

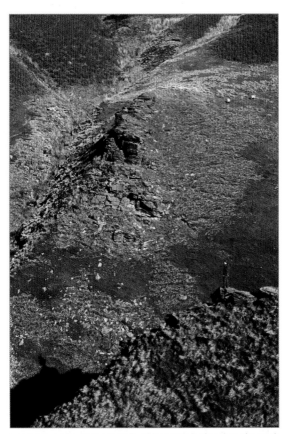

Landslips and autumn tints in Abbey Brook Clough in the Dark Peak of Derbyshire, October 1995.

weather photographs are unbelievably striking – a weather eye if ever there was one.

Certain areas were obvious favourites, the ones he walked through, photographed and wrote about in *The Guardian* for instance. He was particularly taken with the rolling Shropshire countryside and its neighbours; Worcestershire, Herefordshire and Powys. The Yorkshire Dales and northern Pennine moorlands were visited frequently, and up into Scotland via Northumberland to the gentler slopes of Angus, Perthshire, and Fife, and then across to the magnificent peaks of the north-west Highlands.

But it was the Peak District of Derbyshire (and Cheshire, Staffordshire, West and South Yorkshire) that was the landscape Roger knew best, and the one he regarded as home. It was where, in the early 1950s, he spent a couple of years on a farm at Unthank in the Cordwell Valley learning the rudiments of agriculture. This work experience was on a farm that two years later would straddle the actual boundary of the newly-born Peak District National Park – Britain's first, and the culmination of a process that had dragged on for over 20 years.

The next year was spent at Broomfield Hall, Derbyshire's College of Agriculture to gain a National Certificate in Agriculture, followed by

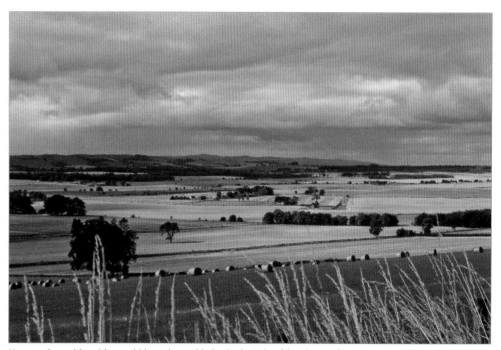

Harvest time with golden stubble and round bales in the Vale of Strathmore from near Tigerton, Angus in August 1999.

another year learning the rudiments of education at Worcester College; then onwards for another 40 years or so imparting that knowledge and passion for the British countryside to so many of his pupils in three different schools.

Roger's childhood in Dronfield, then a small industrial town midway between Sheffield and Chesterfield, was but a short bicycle ride from

the nearest boundary of the Park. From the mid-1960s he moved to Old Brampton, a village west of Chesterfield that was even closer.

Its name, the Peak District, is something that caused him great consternation, particularly when it inevitably became shortened to 'the Peaks'. He wrote about it in uncharacteristically vehement terms in his last published work,

Peak Passions, the Guardian e-book. I'll let him explain: *The Peak District covers a large area of the southern Pennines and takes its name from the tribe that once inhabited it. There is no connection with this upland and a description of the topography – this is not a district of pointed, peaky hill shapes; few British uplands have such a dearth of such dramatic landforms. No, this is the land of the Peacs so those ignorant enough to use the annoying term 'the Peaks' should immediately alter their ways and go for the proper 'Peak District'.*

With that rant out of the way we are free to forge ahead and discover the spirit of place that is these southern Pennines. In my lifetime wanderings of Peakland (another acceptable label) I have come to realize that most of the best spots are far from the popular 'honeypots' spoiled by the hordes who rarely venture far from the broad highway. So much the better for the discerning minority who love remoteness and piled up history.

It's a theme that recurs often in his writings. Not for him the throngs of Bakewell, Castleton, Matlock, Dovedale and the like, although he did have a secret affection for the village of Hathersage, nestling under one of the more dramatic gritstone edges and home to a favourite tearoom. So much so that in his later

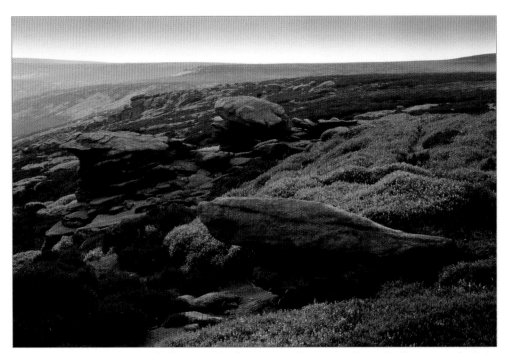

'I see no peaks!' A July 1981 image looking up Coldwell Clough past The Shepherd's Meeting Stones towards Kinder Scout, the highest point in the Peak District. As Roger has so forcefully described, there are no dramatic jagged pinnacles here, just a flat, featureless moorland plateau. Elsewhere there are a few tops with distinctive profiles that can be recognised from afar, but not as many as 'Peak' District would suggest.

years he was actually contemplating buying a house there.

With a car, a motorbike and a bicycle in his garage he could frequently be found making his way westward into the Peak District on any one of them. Being a teacher, the long school holidays meant that visits to a favourite Dark Peak moorland, or to help out on a local farm, or for a climb on a gritstone edge could be made mid-week rather than at busier weekends.

Farm and sheep sales were a popular attraction too, because it brought together in

one place countryfolk whose lifestyle he was interested in and could relate to. He liked to watch, listen and chat with them, to ask questions in order to learn more about the way they lived.

He watched and worried that open access and the coming of the post-war motor car had brought throngs of people in such numbers, particularly at weekends, that the environment would have difficulty sustaining them and all their cars, coaches and motorbikes and would be damaged. In 1992 he wrote, *The wholesale industrialisation of the Peak District fringes, both to east and west, concentrated a massive captive population who were waiting for the chance to break out into the fresh air and sunshine. Now we have great open spaces to explore, and the means to get to them. Some say we have opened a Pandora's box – the railway brought the first vandals to Peakland, the car brings the multitudes that reduce paths to broad quagmires in popular places, and the cult of the mountain bike threatens ancient tracks. Lucky though, the wanderer who strays into far off country, who still enjoys the quiet hills, distant from car park and gravel path and busy dale. Ghosts of long gone farmers still inhabit curlew moors, and far views to distant lowlands are quite unaltered.*

In his lifetime there wasn't a corner of the Peak District he hadn't visited or a peak he hadn't trodden, and even the honeypots had received brief glances over the decades. He knew every inch of its varied landscapes – from the high boggy moorlands of Bleaklow and Kinder Scout to the dry valleys and grassy plateaus of the White Peak further south.

Often his only companions were the grouse and skylarks of high summer or the sheep and mountain hares of deepest winter as he explored the rich hidden corners and lonely wildernesses that stretched over six counties. He always had his camera with him to record his walk; the unexpected encounter with flora or fauna, the rich colours and dramatic shapes of

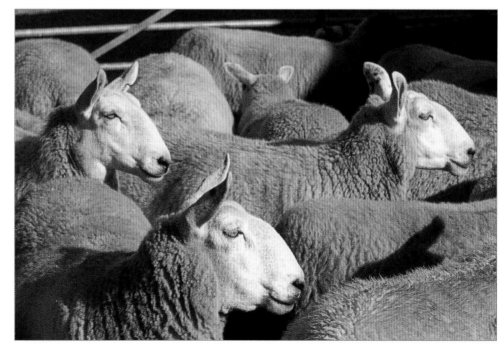

Cheviot ewes at Unthank Lane Farm in October 1984.

an unforgettable landscape, or a dazzling winter sunset – all composed with a countryman's eye for detail. Most of these have never appeared in print before and are just a tiny fraction of the treasure trove I've been privileged to pick from. Enjoy then, some of his finest images of the British countryside he walked for over 60 years.

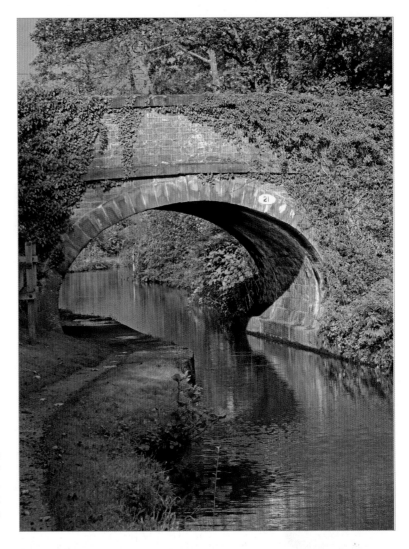

The last one. Roger would be the first to admit that this tranquil scene at Bridge No. 21 over the Macclesfield Canal near Adlington in Cheshire is not as dramatic or memorable as some of the images you'll see as you turn the pages of this book. But it is unique, because it's the last one he ever took. Dated 18th October 2011 at 15.28, it marks the end of Roger Redfern's photography. Seventeen days later, on 4th November, he died.

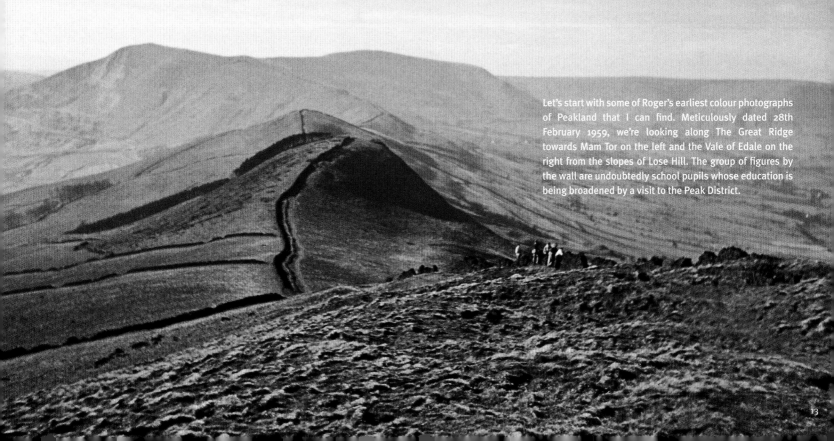

PEAKLAND DAYS
The landscapes of home

Let's start with some of Roger's earliest colour photographs of Peakland that I can find. Meticulously dated 28th February 1959, we're looking along The Great Ridge towards Mam Tor on the left and the Vale of Edale on the right from the slopes of Lose Hill. The group of figures by the wall are undoubtedly school pupils whose education is being broadened by a visit to the Peak District.

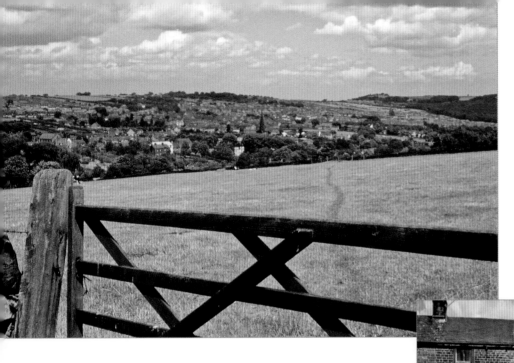

This is Dronfield, a small industrial town in the valley of the River Drone where he was brought up and lived until the mid-1960s. Local coal and iron ore led to it becoming a centre for 'edge' tool manufacture such as sickles, scythes, spades, etc. in the 19th century. The 20th century housing estates for Sheffield and Chesterfield commuters that sprawled up and over the skyline, one of which is visible on the left-hand side of this July 1960 view, drove him to a more rural idyll a few years later. This gate gives access to Finney Fields where he used to play, and to the heart of the old town beyond. It's now covered by houses, tarmac and concrete of what, at the time, was claimed to be Europe's largest private housing estate. In June 1991 he wrote with some nostalgia that, . . . *a sea of bricks and mortar covers the valley sides beyond the oasis of playing field; a huge private housing estate has swept over the land, right up to the familiar horizon where once it was possible to make out the distant silhouettes of grazing cows.*

This is the heart of the town in May 1967. In the centre of the High Street is the Peel Monument, erected in 1850 to commemorate the repeal of the hated Corn Laws in 1848. It was once a meeting place for the children and menfolk of the town, but now it's just a marker for the entrance to the town's dreary civic centre. Directly behind the monument is Roger's second home in the town, The Cottage, a rather grand 1622 stone construction that was once owned by Lord Byron, although there is no evidence that he actually lived there. A bed of wallflowers add a dash of colour to what would otherwise be a rather drab scene.

The rapid urbanisation of Dronfield during the 1960s, coupled with the death of his father, prompted a move in 1967 to a more rural environment that was only a couple of miles from the Peak District National Park boundary. Old Brampton, a village perched on a ridge on the western outskirts of Chesterfield was where he made his home in another cottage until his death in 2011. It was a village I imagine to be very much like the Dronfield he would have recognised as a boy. It was once on the main road between Chesterfield and Bakewell until a more direct A619 was built.

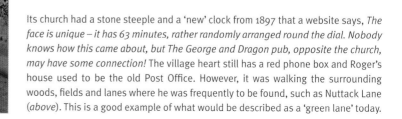

Its church had a stone steeple and a 'new' clock from 1897 that a website says, *The face is unique – it has 63 minutes, rather randomly arranged round the dial. Nobody knows how this came about, but The George and Dragon pub, opposite the church, may have some connection!* The village heart still has a red phone box and Roger's house used to be the old Post Office. However, it was walking the surrounding woods, fields and lanes where he was frequently to be found, such as Nuttack Lane (*above*). This is a good example of what would be described as a 'green lane' today.

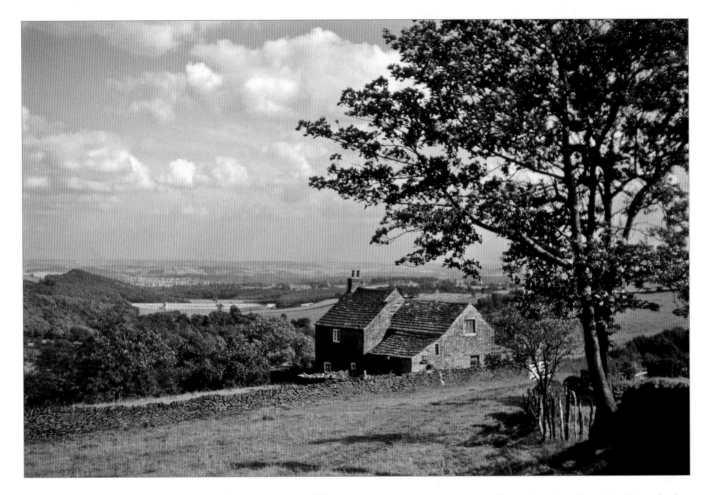

To the north of the village was the valley of the Linacre Brook which has three dams across it to provide Chesterfield's water. High up at the top of the valley was Birley Farm, a traditional farmhouse of stone walls and stone slates that commanded magnificent views down the valley. Above the dam wall we can just see the roofs of a new housing estate creeping outwards from Chesterfield in September 1963.

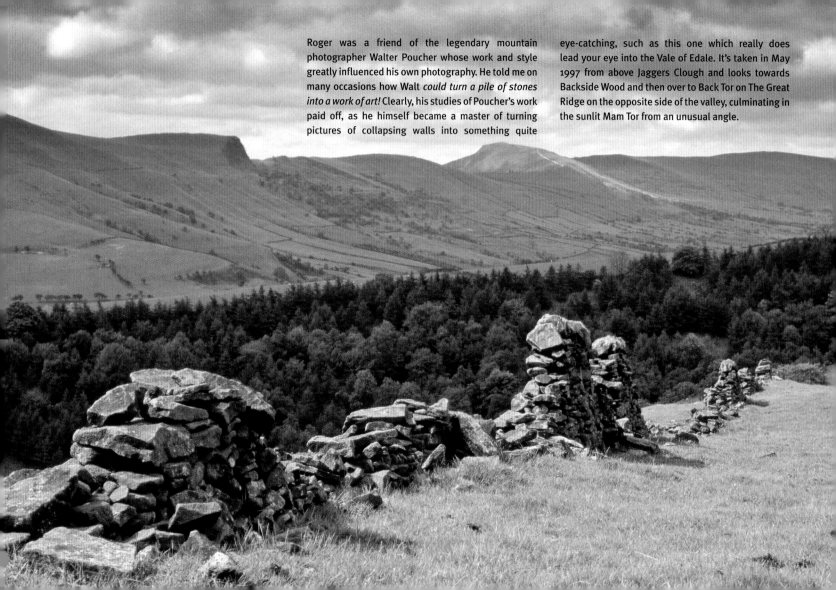

Roger was a friend of the legendary mountain photographer Walter Poucher whose work and style greatly influenced his own photography. He told me on many occasions how Walt *could turn a pile of stones into a work of art!* Clearly, his studies of Poucher's work paid off, as he himself became a master of turning pictures of collapsing walls into something quite eye-catching, such as this one which really does lead your eye into the Vale of Edale. It's taken in May 1997 from above Jaggers Clough and looks towards Backside Wood and then over to Back Tor on The Great Ridge on the opposite side of the valley, culminating in the sunlit Mam Tor from an unusual angle.

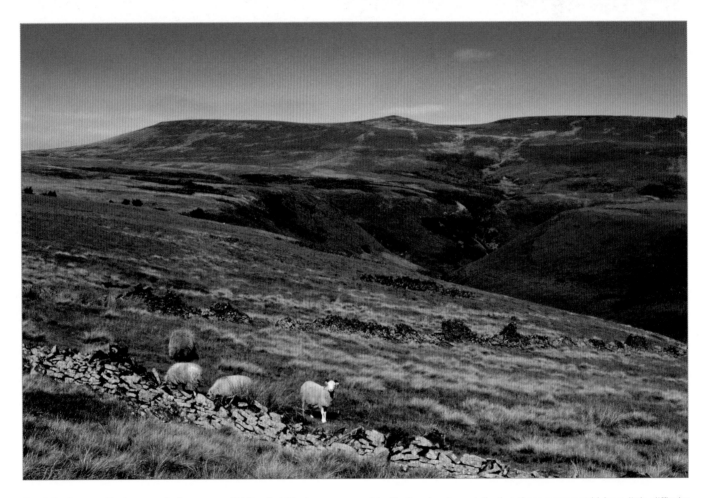

Here's further proof in August 1984 from a 1,329ft hill called Pike Low over-looking the Derwent Dam wall. It's an area littered with old stone boundary walls, most of which are in serious disrepair. Here we can see a couple of ineffective dry-stone walls that these ewes would have little difficulty clambering over. The carpets of purple heather and green bracken are at their best. The small pinnacle on the skyline is the intriguingly-named Lost Lad.

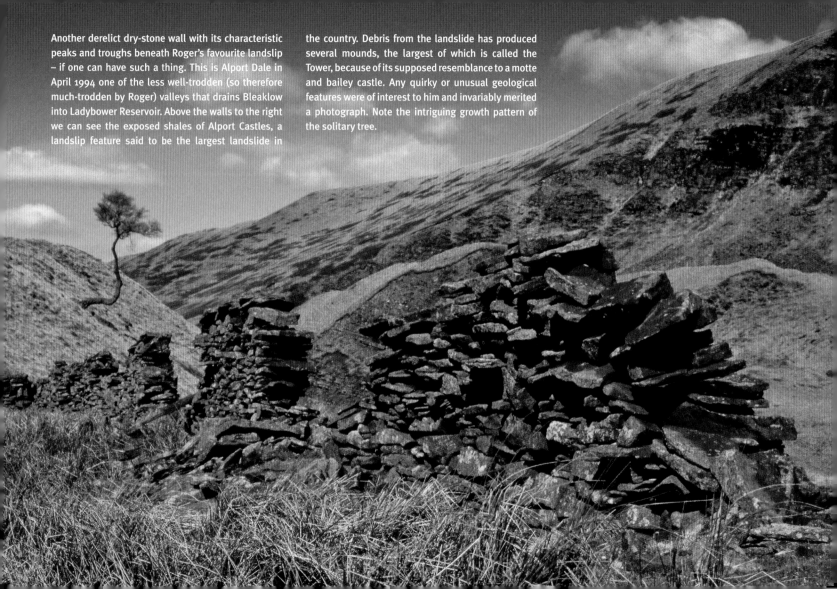

Another derelict dry-stone wall with its characteristic peaks and troughs beneath Roger's favourite landslip – if one can have such a thing. This is Alport Dale in April 1994 one of the less well-trodden (so therefore much-trodden by Roger) valleys that drains Bleaklow into Ladybower Reservoir. Above the walls to the right we can see the exposed shales of Alport Castles, a landslip feature said to be the largest landslide in the country. Debris from the landslide has produced several mounds, the largest of which is called the Tower, because of its supposed resemblance to a motte and bailey castle. Any quirky or unusual geological features were of interest to him and invariably merited a photograph. Note the intriguing growth pattern of the solitary tree.

Signposts were not normally things that Roger needed, he knew just about every footpath and bridleway in the Peak District. But they did add some foreground interest to his photographs, like this one in the Woodlands Valley in July 2010. In the valley bottom is Rowlee Bridge from about 1832, a Grade II Listed structure and SSSI that was a convenient crossing of the River Ashop en route from Kinder Scout to Derwent Dale. It's here that the Edale Shales and Mam Tor Sandstones on the southern bank are bent into sharp, symmetrical folds. This interesting geological feature is called valley bulging and it occurs where soft strata (the Edale Shales) are forced upwards in a valley by the weight of the hills on either side. The folding results from the compression and buckling of the rocks during the bulging process. These are probably the best examples of this phenomenon currently known in Britain.

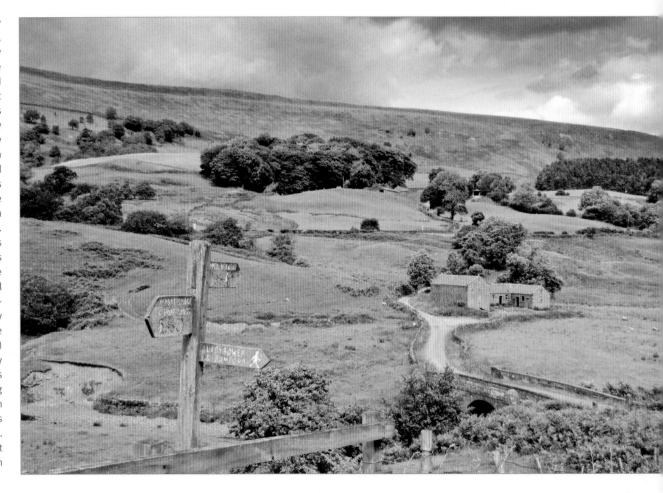

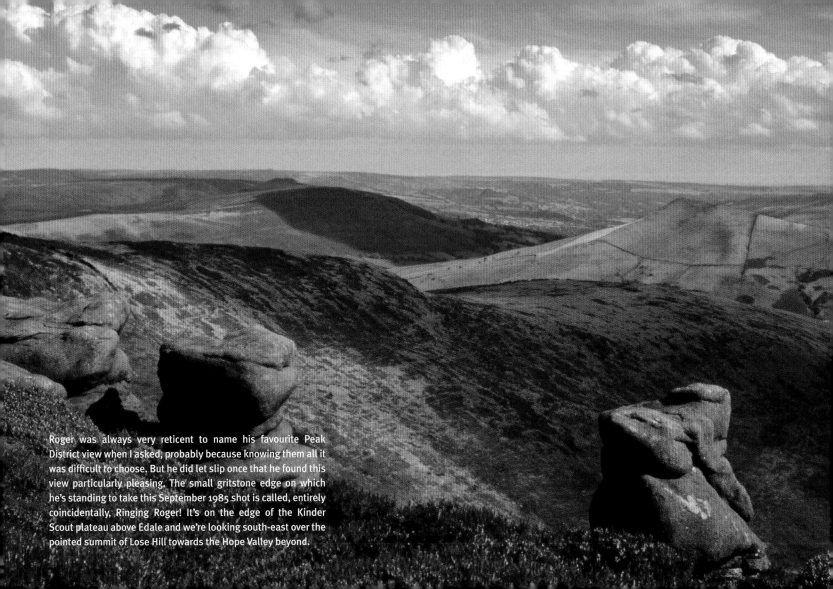

Roger was always very reticent to name his favourite Peak District view when I asked, probably because knowing them all it was difficult to choose. But he did let slip once that he found this view particularly pleasing. The small gritstone edge on which he's standing to take this September 1985 shot is called, entirely coincidentally, Ringing Roger! It's on the edge of the Kinder Scout plateau above Edale and we're looking south-east over the pointed summit of Lose Hill towards the Hope Valley beyond.

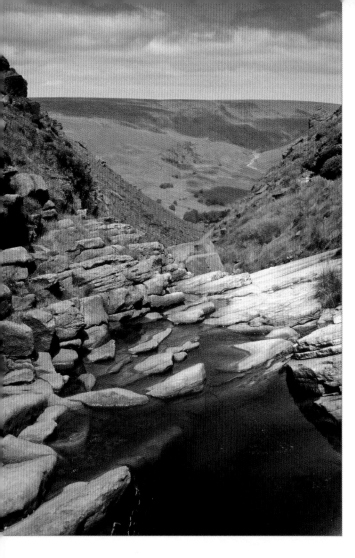

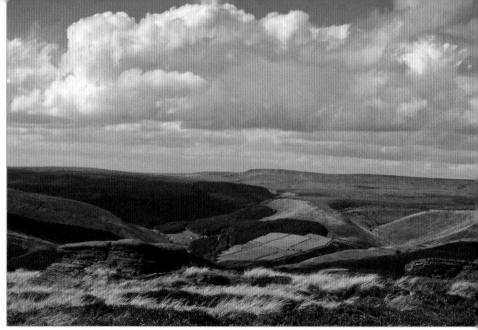

The wildness and isolation of the Dark Peak was where Roger returned time and again, to places like Bleaklow and the Higher Shelf Stones in September 1985. In *Peak District Memories* (1997) he wrote, *The scenery of the high gritstone plateaux – Black Hill, Bleaklow, Kinder Scout – can be exquisite or sickeningly squalid, depending on the weather. The area is sublime for the reasons of obtaining solitude (only game birds and mountain hares for companions). In these days of bulldozers and mushrooming building sites it's reassuring to know of some place that will not change from what it has been for thousands of years - and be able to escape to the fastnesses of Bleaklow for the peace of the soul.*

This is Wildboar Clough where it cuts through Bleaklow's northern escarpment. The dark brown peaty water is typical of most Dark Peak streams close to their source. Beyond, across the Longdendale valley we're looking at Laddow Rocks and the well-trodden Pennine Way footpath in May 2005.

Winter passage across the boggy wilderness of Kinder Scout or Bleaklow is much easier when the peat and the water in the streams is frozen.

On a day like the one depicted the going is easy, the ground gripped by deep frost.

Swift progress can be made through the solid stream beds and groughs, as this view from December 1995 shows. The slight hump on the horizon is actually the highest point of Kinder Scout and the whole of the Peak District. Its 2,088ft elevation is not marked in any way at all – the nearest trig point is another mile away at Kinder Low, 2,077ft.

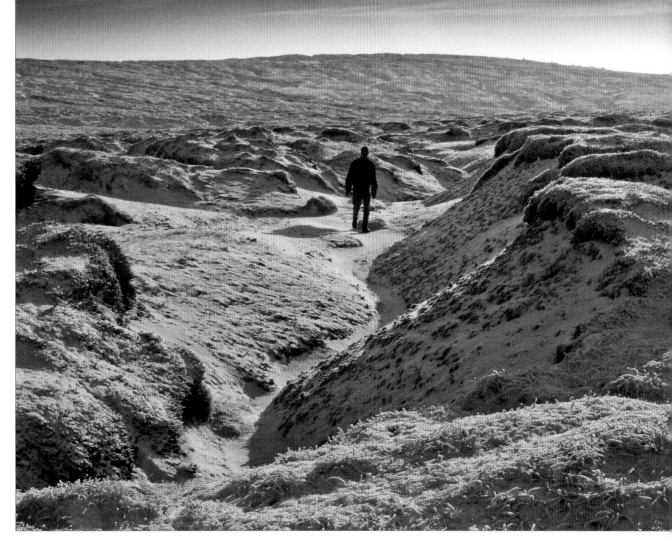

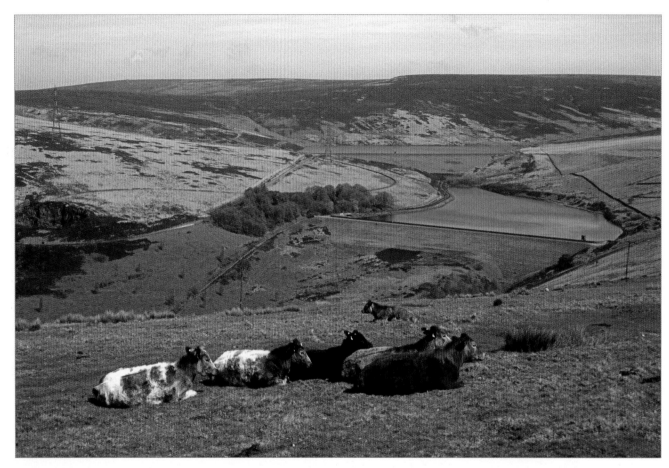

In its north-western corner the Peak District National Park extended almost into the suburbs of places like Saddleworth. This is a view taken a mile or so outside the Park boundary above Swineshaw Reservoirs near Stalybridge in May 2006, and if we could see just a little further to our left we'd have a clear view of the high-rise buildings in Manchester city centre. It was an area he frequented often; his first teaching post was close by this corner of the Peak District, so too was L.S. Lowry's last home in Mottram. He was a great admirer of Lowry's work and even illustrated some of his own books with pen and ink sketches.

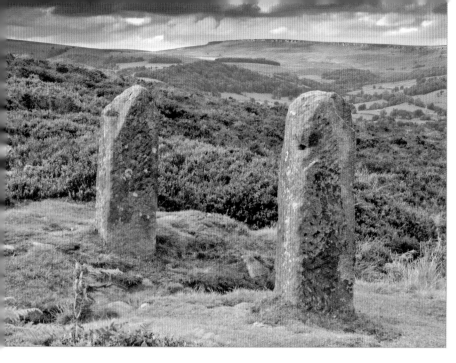

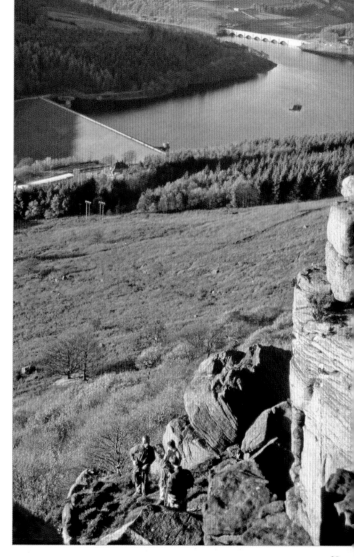

A digital image of Hathersage and Stanage Edge, one of the longest Peak District edges that stretches for almost the entire skyline in this May 2010 view through what appears to be an old field gateway on Eyam Moor. To the right of the two pillars, beyond the carpet of heather and bilberry, we can just make out the spire of Hathersage's parish church, in the graveyard of which can be found Little John's Grave.

Being a climber, Roger practised and honed his skills on the gritstone edges of the Peak District – from which there were many to choose. In a *Country Diary* from 2010 he wrote that, *The climbing routes on Bamford Edge are not particularly long but their superb position makes them memorable; the effect is of a lofty mountainside far above the everyday world.* Here we can see a party of climbers on Bamford Edge on a wonderful winter's day in December 2004 above a field of golden bracken and the dam wall of Ladybower Reservoir.

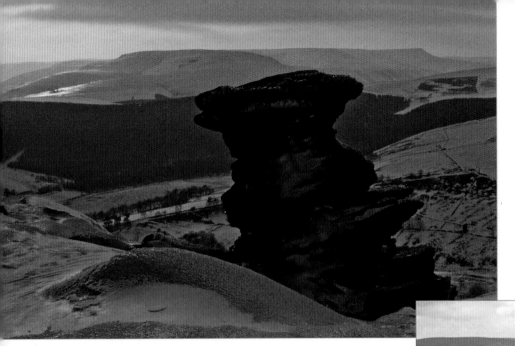

These are some views from the top of Derwent Edge looking west. Scattered along its length are an assortment of isolated gritstone pinnacles or tors, many of which have been weather-blasted over the millennia into weird shapes and been given supposedly descriptive names such as The Coach and Horses, The Cakes of Bread, The Wheel Stones, etc. One of the most well-known is this one, the Salt Cellar. The winter view is from March 1986 and shows the Salt Cellar, caked in snow and ice, in front of a magnificent sunset over Kinder Scout. In Peakland Days (1970) he writes that, . . . *the central part has been weathered to form a narrow stalk supporting the more resistant upper mushroom. Many have been the scramblers marooned on top of the Salt Cellar after climbing on to it, unable to make the more difficult descent.*

Almost exactly the same view but this one was taken on a balmy summer's day in May 1981. The water in the valley bottom is the northern arm of Ladybower Reservoir.

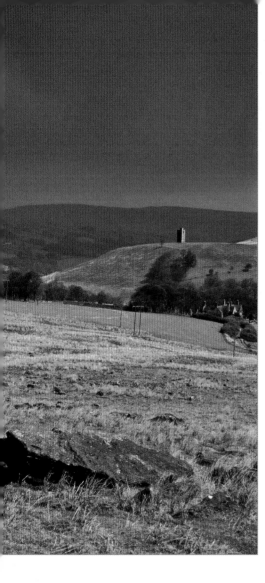
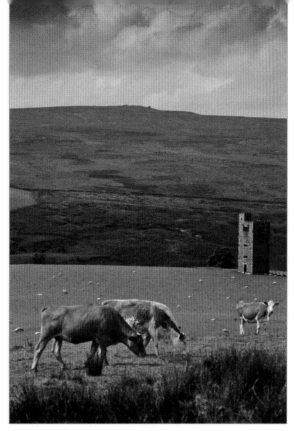
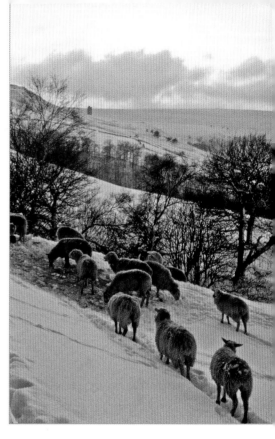

Bradfield Dale is a part of the Peak District that falls within the north-western boundary of the city of Sheffield and Roger often visited its moorland slopes and three reservoirs. Common to all of these views is the stone tower known as Boot's Folly, built by Charles Boot, (son of Henry Boot, founder of the famous Sheffield construction company) in 1927, allegedly to create work for people during the depression. The spring sunshine of April 2001(*left*) catches his tower sitting on its ledge above Strines reservoir. The September 2006 view with Guernsey cows (*centre*) gives a better view of its distinctive castellated architecture. The cluster of stones on the skyline is Dovestone Tor. A picturesque winter scene (*right*) from February 1986 shows sheep eating hay as the sun sets over the distant Boot's Folly.

One of the honeypots that Roger avoided on high days and holidays was Dovedale, particularly at the spot where it emerges from the limestone plateau near the villages of Ilam and Thorpe. At this distance with a flock of sheep grazing contentedly in the foreground, the crossing of the River Dove on the stepping stones by hordes of visitors was both out of sight and out of earshot. Even an on-line guide to Derbyshire's tourist attractions warns, *Keep away on sunny weekend afternoons*, and Roger too wrote, *So popular has Dovedale become that a broad path has had to be constructed to keep the mud at bay. The route along the bottom of the dale is now little different to one through a public park.*

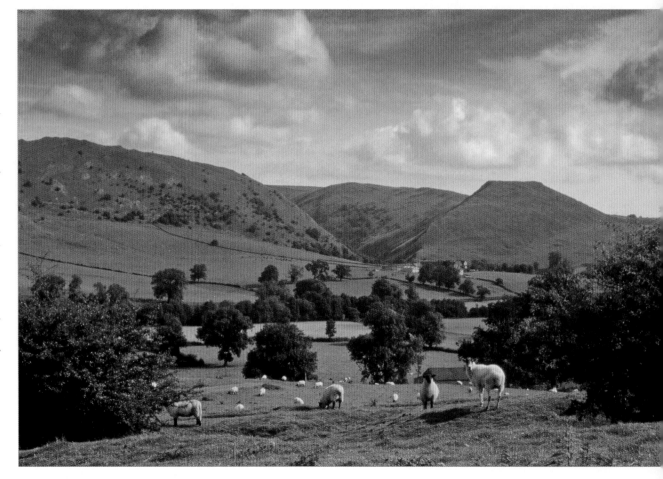

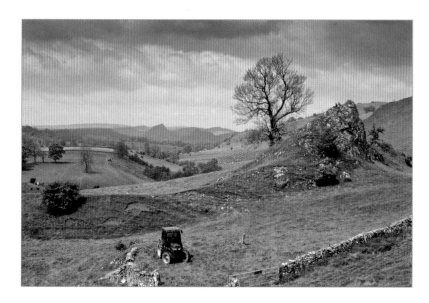

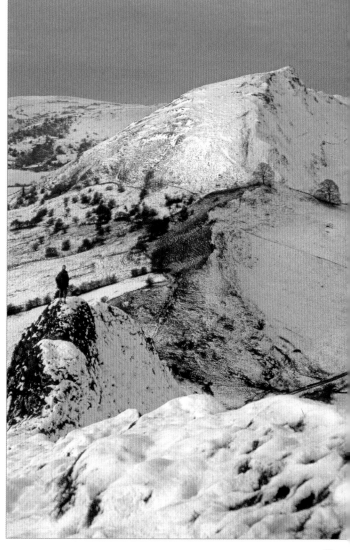

Higher up the Dove Valley its sides open out and it loses the hemmed-in feeling of its lower reaches. Up here we also find three of the White Peaks most shapely hills. This is a view of the remaining mounds of Pilsbury Castle from May 1999. The red tractor has been parked perfectly and the solitary tree has yet to grow its new leaves. But it's the background landscape that draws our eye, because these are the impressive profiles of Hollins, Chrome and Parkhouse Hills, remains of an ancient atoll when this part of the Peak District was covered by a tropical sea. Chrome and Parkhouse Hills are a designated SSSI because of their geology and flora.

A fall of winter snow in December 2004 blankets Parkhouse and Chrome Hills. There are several exhilarating walks that take in both summits. In *Walking in Peakland* (2001) he writes that, . . . *continued activity on the part of frost, rain, wind and sun has dramatised their profiles – a process which is still going on. It is an interesting exercise to imagine what these twin hills will look like in another 5000 years!*

Another of the White Peak's much-visited dales is the Manifold Valley, a lush green vale enclosed by steep sides and limestone cliffs at the very southern extremity of the Peak District National Park. There is much of archaeological interest in this valley to be found in the concentration of ancient caves along its length. This was also the route of the delightful Leek & Manifold Valley Light Railway that used to carry milk from the dairy farms in the area to the mainline at Waterhouses. Sadly, it only lasted from 1904 to 1934, dogged by a fairly perceptive observation from a navvy building it that, *it starts from nowhere and finishes up at the same place,* but its route through the winding valley bottom can still be walked or cycled today.

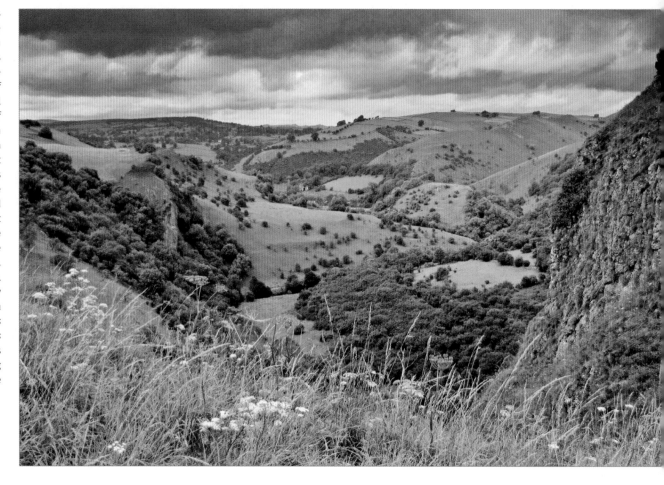

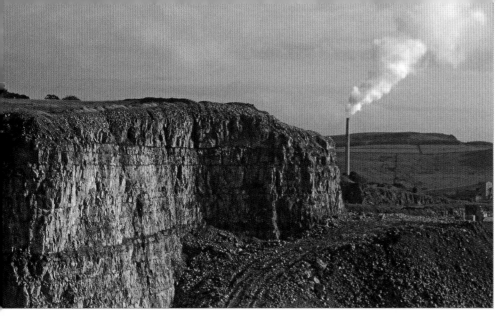

Our insatiable desire for limestone for industry has meant that many places in the White Peak are scarred by gigantic quarries. They have changed the White Peak landscape irreparably as the geology is blasted out for road foundations, smelting steel and making cement, to name but a few uses. The actual faces and terraces of quarries, while undoubtedly a desecration of a once beautiful landscape, held a strange fascination for Roger who had considerable knowledge of local geology.

Its dramatic exposure in the giant quarries of Tunstead (*left*), Hope (*below left*) and Wardlow Quarry on the Staffordshire border (*below*) appealed photographically. The beds and colours of the exposed strata could make attractive images, even though he once described the limestone quarrying industry as an *affront to the landscape*. When exposed by blasting like this the Carboniferous Limestone is tinged with hues of orange, and only prolonged weathering produces the more familiar grey colour of the dry-stone walls and houses.

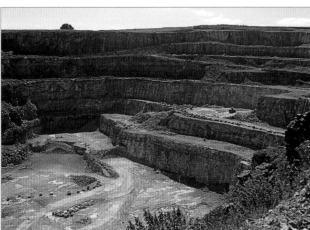

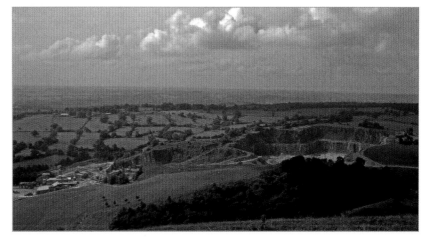

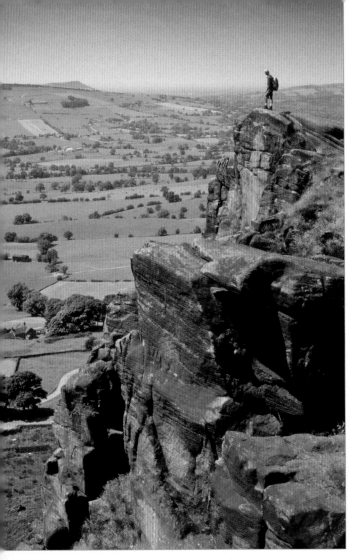

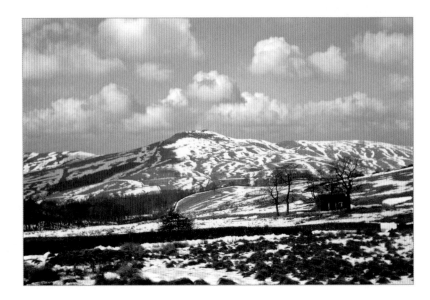

The Peak District National Park extends westward into Cheshire and Staffordshire where there are some notable peaks and edges before the Pennines finally drop onto the Cheshire Plain. Roger considered that, *Some of the most beautiful and romantic countryside of the Peak District is found outside Derbyshire, to the west, in eastern Cheshire.*

Hen Cloud from July 2005, part of a prominent gritstone ridge known as The Roaches situated north-east of Leek in Staffordshire. In *Peak District Memories* (1997) he describes how, *the coarse gritstone forming these edges has weathered into the most attractive forms where scramblers can enjoy themselves for hours on end.* On the horizon we can see a profile of Cheshire's most famous peak, Shutlingsloe.

Shutlingsloe in the winter of February 1968. Cheshire's third highest peak is a popular destination for weekend walkers, being within easy reach of the populations of Cheshire, Derbyshire and Manchester. Roger wrote that, *No matter which way you look at Shutlingsloe it's an unmistakable shape.*

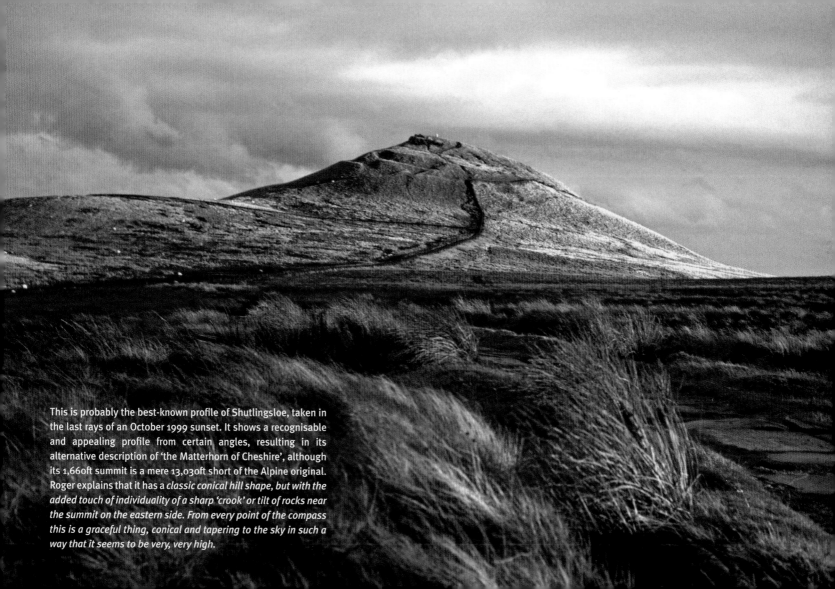

This is probably the best-known profile of Shutlingsloe, taken in the last rays of an October 1999 sunset. It shows a recognisable and appealing profile from certain angles, resulting in its alternative description of 'the Matterhorn of Cheshire', although its 1,660ft summit is a mere 13,030ft short of the Alpine original. Roger explains that it has a *classic conical hill shape, but with the added touch of individuality of a sharp 'crook' or tilt of rocks near the summit on the eastern side. From every point of the compass this is a graceful thing, conical and tapering to the sky in such a way that it seems to be very, very high.*

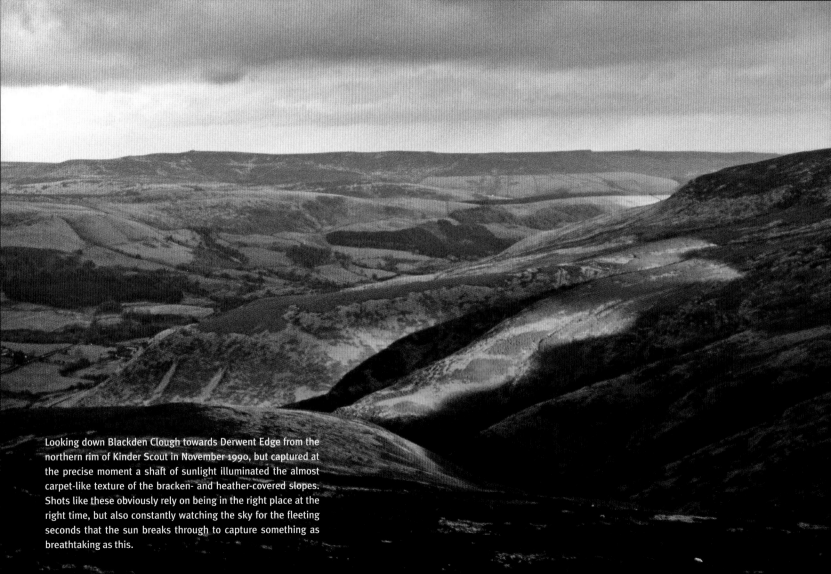

Looking down Blackden Clough towards Derwent Edge from the northern rim of Kinder Scout in November 1990, but captured at the precise moment a shaft of sunlight illuminated the almost carpet-like texture of the bracken- and heather-covered slopes. Shots like these obviously rely on being in the right place at the right time, but also constantly watching the sky for the fleeting seconds that the sun breaks through to capture something as breathtaking as this.

OVER HILL AND DALE
Distant landscapes

Winter feeding on Brown Clee Hill, Shropshire, December 1999.

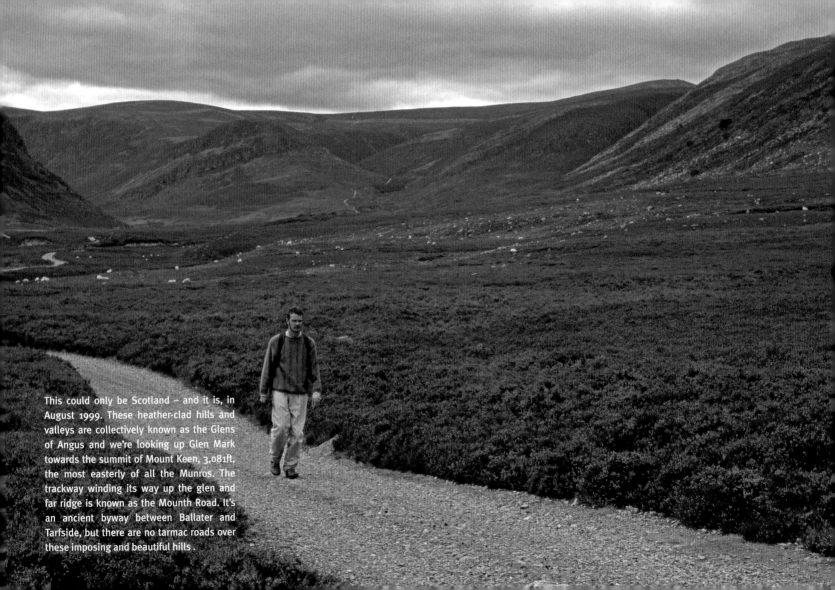

This could only be Scotland — and it is, in August 1999. These heather-clad hills and valleys are collectively known as the Glens of Angus and we're looking up Glen Mark towards the summit of Mount Keen, 3,081ft, the most easterly of all the Munros. The trackway winding its way up the glen and far ridge is known as the Mounth Road. It's an ancient byway between Ballater and Tarfside, but there are no tarmac roads over these imposing and beautiful hills .

The Black Mount group of hills in Scotland take their name from the Black Mount Forest that once used to cover all of these slopes, but as a result of climate change and later deforestation few of the native trees have survived. It's a bleak rocky upland close to the desolate Rannoch Moor with Loch Tulla seen here in the foreground. A late afternoon sun in October 1980 and the orange tints of the larch trees in the foreground and bracken beyond give this image a warm autumn glow.

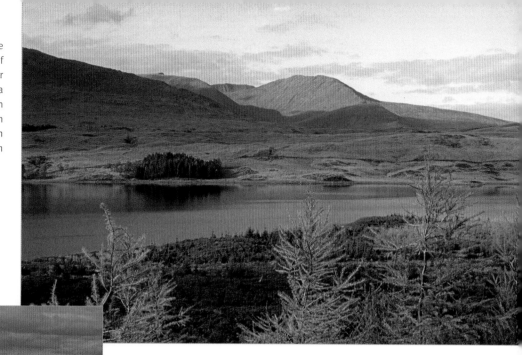

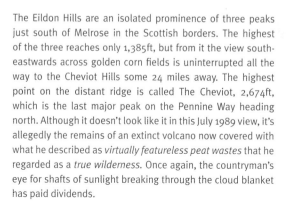

The Eildon Hills are an isolated prominence of three peaks just south of Melrose in the Scottish borders. The highest of the three reaches only 1,385ft, but from it the view south-eastwards across golden corn fields is uninterrupted all the way to the Cheviot Hills some 24 miles away. The highest point on the distant ridge is called The Cheviot, 2,674ft, which is the last major peak on the Pennine Way heading north. Although it doesn't look like it in this July 1989 view, it's allegedly the remains of an extinct volcano now covered with what he described as *virtually featureless peat wastes* that he regarded as a *true wilderness*. Once again, the countryman's eye for shafts of sunlight breaking through the cloud blanket has paid dividends.

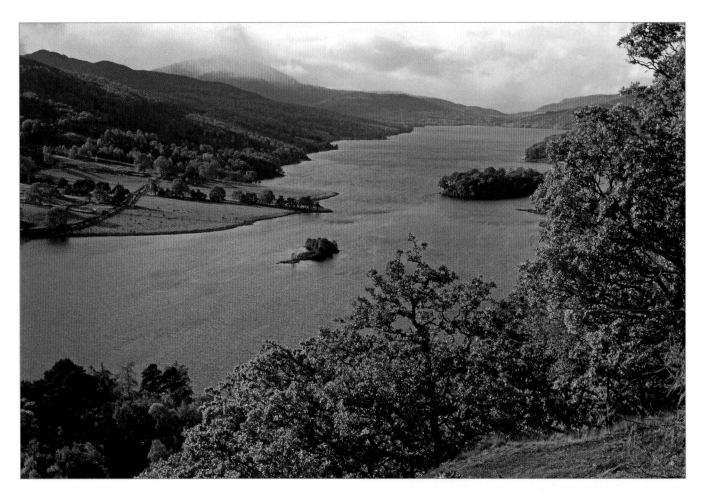

The first tints of autumn appear on the trees along the shores of Perthshire's Loch Tummel in October 1981. This is probably taken from the viewpoint known as Queen's View. In the distance, with its summit just emerging from the mist, is the 3,553ft Schiehallion – a mountain that holds a unique place in scientific history due to a 1774 experiment in 'weighing the world'.

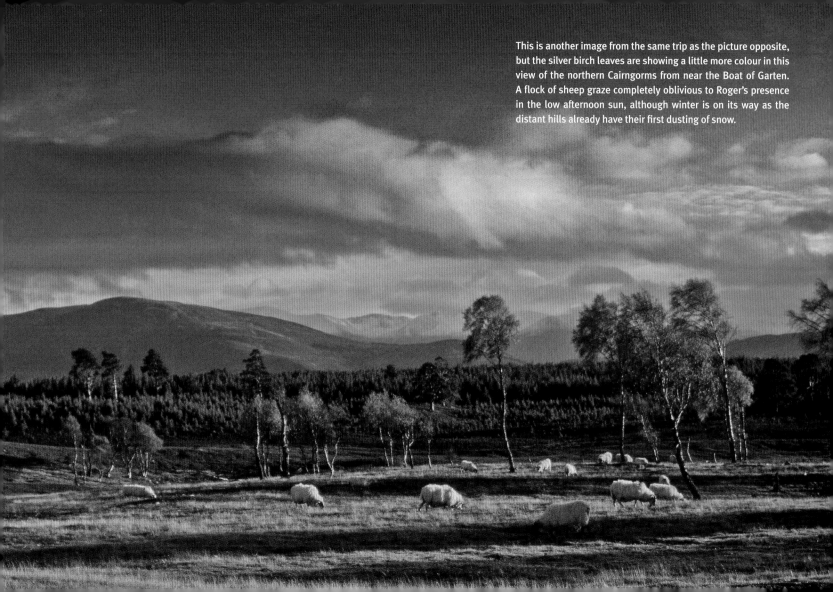

This is another image from the same trip as the picture opposite, but the silver birch leaves are showing a little more colour in this view of the northern Cairngorms from near the Boat of Garten. A flock of sheep graze completely oblivious to Roger's presence in the low afternoon sun, although winter is on its way as the distant hills already have their first dusting of snow.

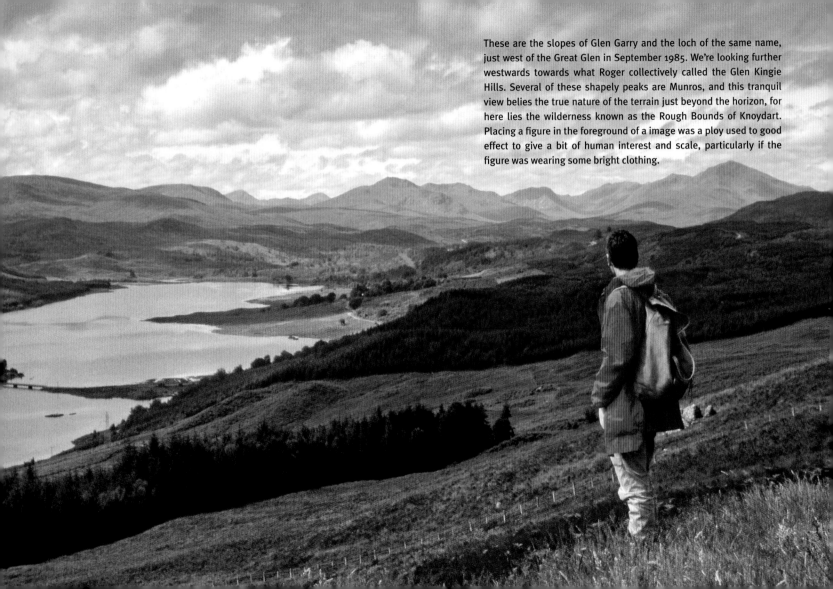

These are the slopes of Glen Garry and the loch of the same name, just west of the Great Glen in September 1985. We're looking further westwards towards what Roger collectively called the Glen Kingie Hills. Several of these shapely peaks are Munros, and this tranquil view belies the true nature of the terrain just beyond the horizon, for here lies the wilderness known as the Rough Bounds of Knoydart. Placing a figure in the foreground of a image was a ploy used to good effect to give a bit of human interest and scale, particularly if the figure was wearing some bright clothing.

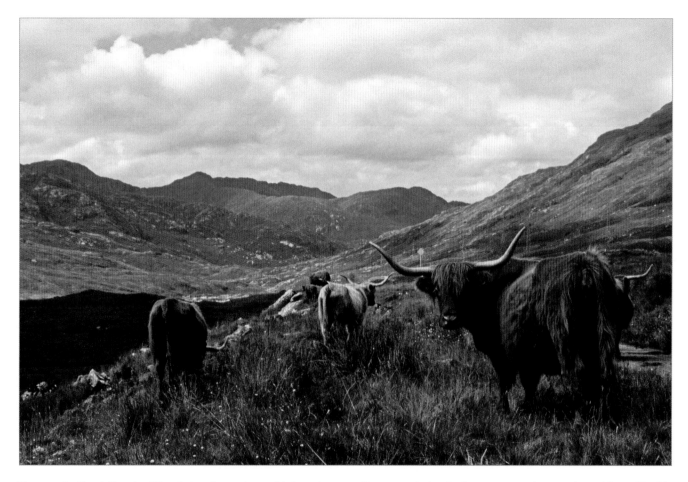

These are the Rough Bounds of Knoydart, an image that could almost have been used for the lid of a shortcake tin. It's a harsh and remote terrain that is sometimes referred to as Britain's last wilderness, only accessible by boat, or by a 16-mile walk through rough country. It has about seven miles of tarmac roads, but they're not connected to any other public road! In this June 1975 shot Roger has met a Highland cow who is obviously not used to visitors in this part of Scotland and gives him a hard stare!

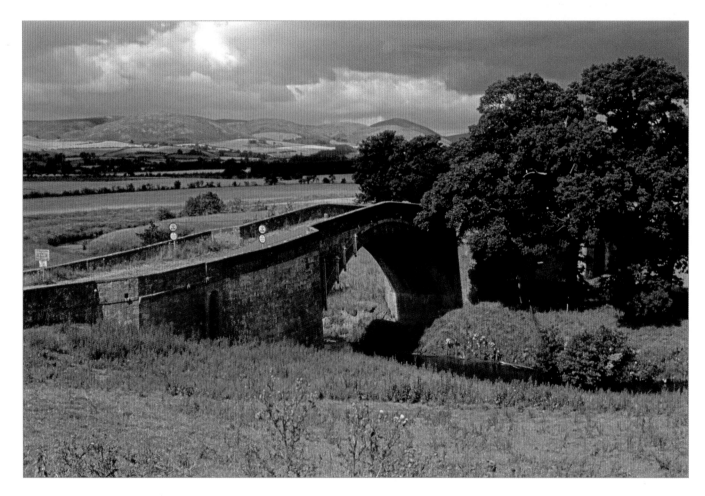

Roger always regarded the landscapes of rural Northumberland to be similar to part of the Peak District he knew so well, except that it had a magnificent coastline as well. The high, graceful arch of 16th century Weetwood Bridge, seen here in July 1989, is a Grade 1 Listed building and a scheduled monument. It crosses the River Till, the only English tributary of the Scottish Tweed. In the distance are the Cheviot Hills.

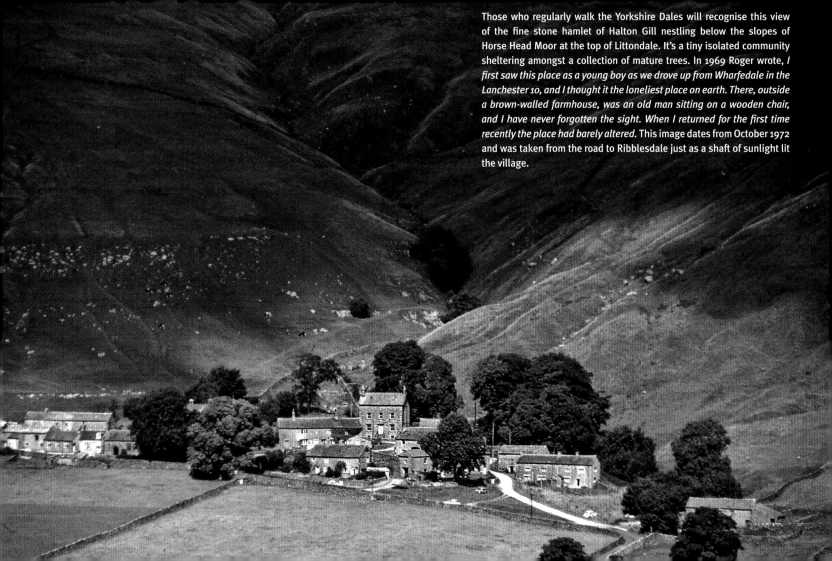

Those who regularly walk the Yorkshire Dales will recognise this view of the fine stone hamlet of Halton Gill nestling below the slopes of Horse Head Moor at the top of Littondale. It's a tiny isolated community sheltering amongst a collection of mature trees. In 1969 Roger wrote, *I first saw this place as a young boy as we drove up from Wharfedale in the Lanchester 10, and I thought it the loneliest place on earth. There, outside a brown-walled farmhouse, was an old man sitting on a wooden chair, and I have never forgotten the sight. When I returned for the first time recently the place had barely altered*. This image dates from October 1972 and was taken from the road to Ribblesdale just as a shaft of sunlight lit the village.

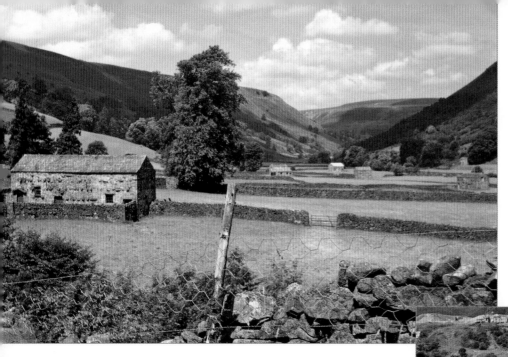

Swaledale is renowned for its delightful limestone field barns, of which there are over 1,700 in this dale alone, dating from 1750–1900. They provided a method of over-wintering cattle where their winter fodder could also be stored, enabling the cows to be milked all year round. Many have been preserved and converted to either permanent dwellings or holiday lets. The view above from July 1969 is looking along Upper Swaledale, *beautiful and lonely – virtually unspoilt by the passage of time,* from near Muker, and the picture on the right shows two similar barns near Keld. Just visible on a ledge above the valley are the remains of the spoil heaps from the 18th and 19th century lead mines that thrived in the dale.

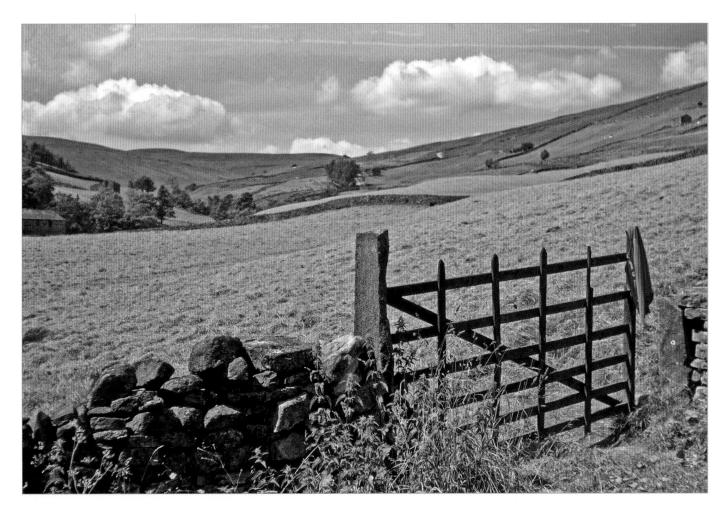

This is higher up Swaledale in its tributary valley of Stockdale near the village of Thwaite. It's haymaking time below Angram Common in July 1969 and the grass has been cut, turned and is nearly ready to be baled. But does the pink cardigan abandoned on the gate belong to the farmer's wife?

The last rays of a July 1969 sunset pick out a couple of sheep grazing on the slopes of Darnbrook Fell, but what about the silhouette of the hill beyond? Does it look slightly familiar? Not often seen from this angle, it's the unmistakable profile of Pen-y-Ghent, the 'crouching lion' of the Yorkshire Dales. Roger was always a keen observer of dramatic cloudscapes and weather as we shall see later in this book, so would often climb to a good vantage point in twilight if the prospect of a spectacular sunset was likely.

In April 1968 the Tan Hill Inn was still whitewashed. Britain's highest public house sits at 1,732ft in the middle of a high boggy basin, the site of countless former coal and lead mines, the last of which closed in 1929. Because it had a tarmac road running past it, local farmers could still use it and so it survived. In *Portrait of the Pennines* (1969) Roger recounts that in late Victorian times, *Eighteen gallons of ale lasted a month in summer and three months in winter at Tan Hill Inn and the landlord said that sometimes eleven consecutive weeks went by without one stranger entering the place.* Nowadays, it's a popular stop for tourists and walkers on the Pennine Way which passes its door.

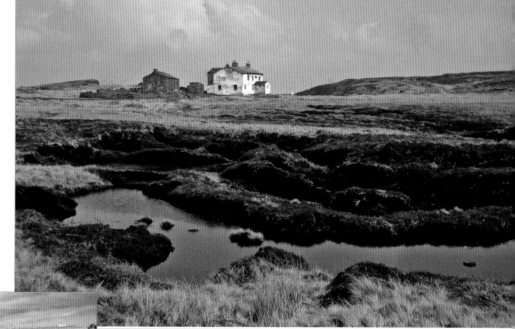

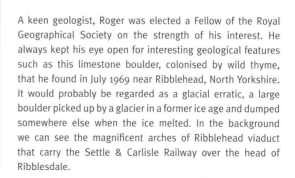

A keen geologist, Roger was elected a Fellow of the Royal Geographical Society on the strength of his interest. He always kept his eye open for interesting geological features such as this limestone boulder, colonised by wild thyme, that he found in July 1969 near Ribblehead, North Yorkshire. It would probably be regarded as a glacial erratic, a large boulder picked up by a glacier in a former ice age and dumped somewhere else when the ice melted. In the background we can see the magnificent arches of Ribblehead viaduct that carry the Settle & Carlisle Railway over the head of Ribblesdale.

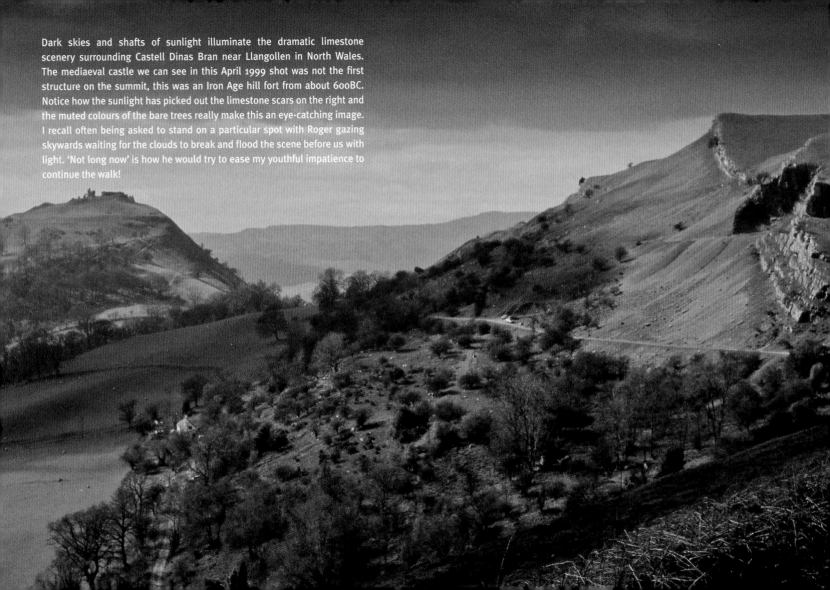

Dark skies and shafts of sunlight illuminate the dramatic limestone scenery surrounding Castell Dinas Bran near Llangollen in North Wales. The mediaeval castle we can see in this April 1999 shot was not the first structure on the summit, this was an Iron Age hill fort from about 600BC. Notice how the sunlight has picked out the limestone scars on the right and the muted colours of the bare trees really make this an eye-catching image. I recall often being asked to stand on a particular spot with Roger gazing skywards waiting for the clouds to break and flood the scene before us with light. 'Not long now' is how he would try to ease my youthful impatience to continue the walk!

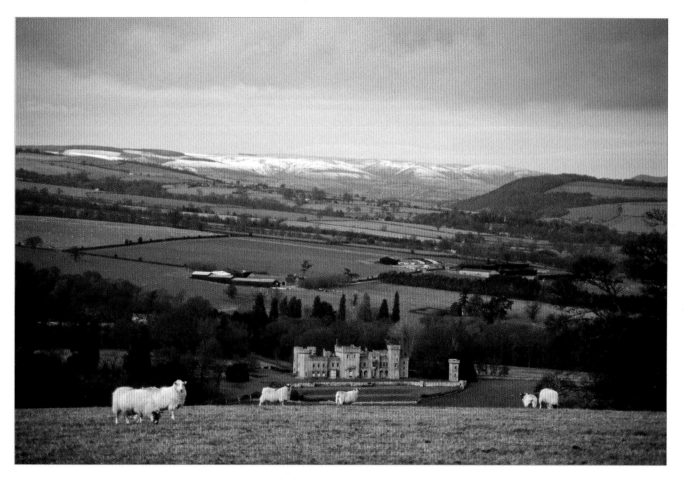

It's called Downton Castle, and its architecture suggests it is one, but it's actually a country house in Herefordshire a few miles west of Ludlow, seen here in December 2003. In a *Country Diary* he reflected that, *This part of the westernmost Midlands is never busy with visitors, and on this day it all seemed to conform to Housman's quietest land under the sun*. There's snow beyond on the distant plateau called The Long Mynd beyond, but still enough grazing to keep the sheep happy in a field overlooking the estate and the Teme Valley.

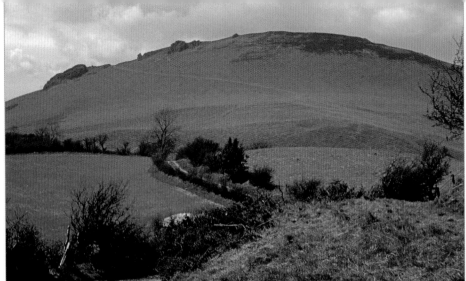

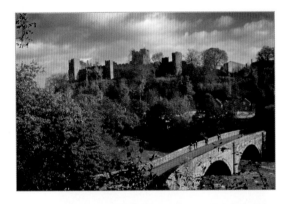

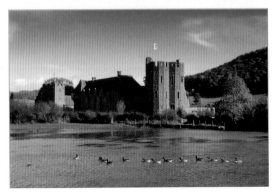

Shropshire was Roger's second favourite English county after Derbyshire. He was captivated by its rolling moorlands, green valleys, magnificent castles and Ludlow, his favourite English town. He roamed its lush meadows and high hills almost every year since the late 1950s.

Ludlow Castle from above Dinham Bridge (*top left*) over the River Teme in October 1998. In 2001 he recalled, *We stood on the wet sward and looked down to the swirling Teme as it raced out of the Welsh borderland. Pedestrians were crossing Dinham Bridge, peering over the parapet at the foaming, brown water where only the bravest ducks venture into midstream at this time of year.* Stokesay Castle (*bottom left*) is a popular location for return visits because of the impressive water meadows in front of the castle. In this view it's just a flock of Canada geese making their way across, but sometimes it would be cattle standing up to their knees in the shallow water.

The distinctively-shaped whaleback hill called Caer Caradoc (*above*), 1,506ft, *one of the shapeliest hills in England*, is formed of highly resistant Precambrian rocks of volcanic origin and rises majestically out of the surrounding plain. He reminisced in a *Country Diary* from 2003 about, *Shapely hills, like Caer Caradoc at the bottom end of Wenlock Edge, overlook superb secret nooks, where you can walk for hours below towering hedgerows.* This is a very early view of Caer Caradoc from the east in April 1960.

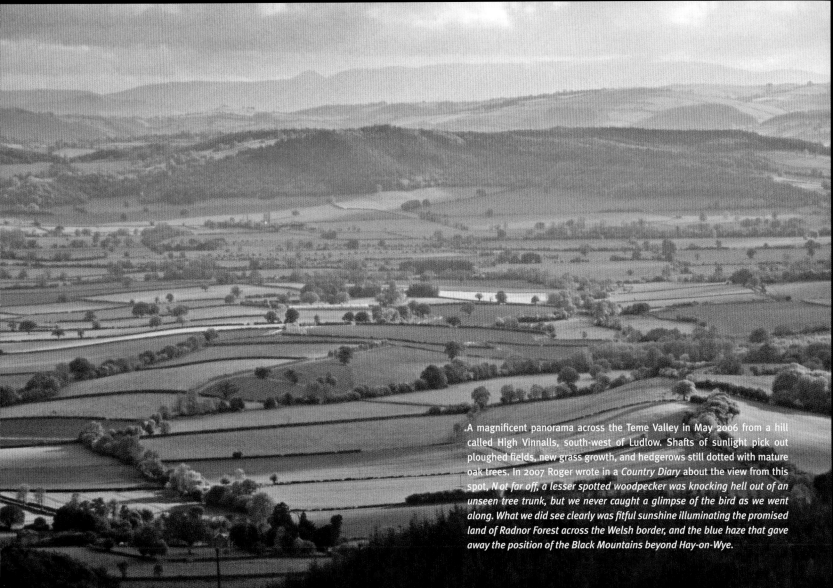

A magnificent panorama across the Teme Valley in May 2006 from a hill called High Vinnalls, south-west of Ludlow. Shafts of sunlight pick out ploughed fields, new grass growth, and hedgerows still dotted with mature oak trees. In 2007 Roger wrote in a *Country Diary* about the view from this spot, *Not far off, a lesser spotted woodpecker was knocking hell out of an unseen tree trunk, but we never caught a glimpse of the bird as we went along. What we did see clearly was fitful sunshine illuminating the promised land of Radnor Forest across the Welsh border, and the blue haze that gave away the position of the Black Mountains beyond Hay-on-Wye.*

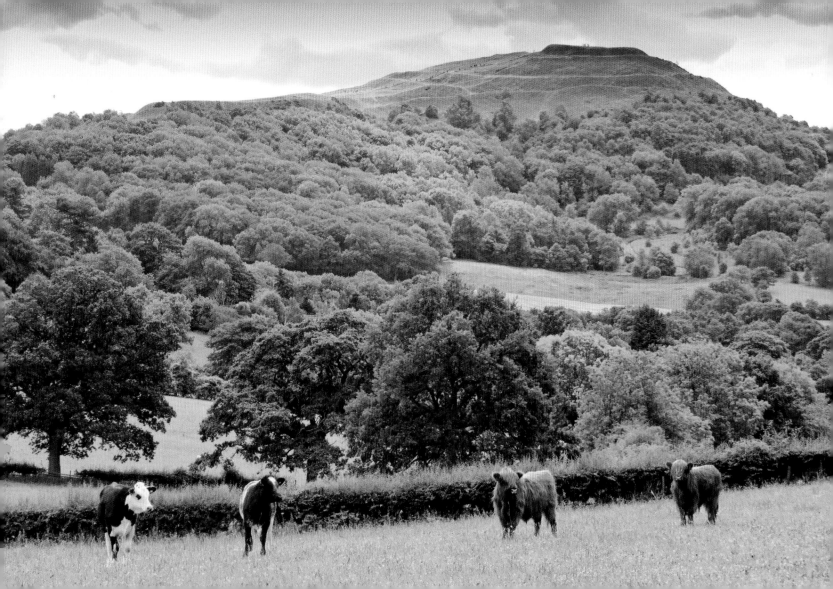

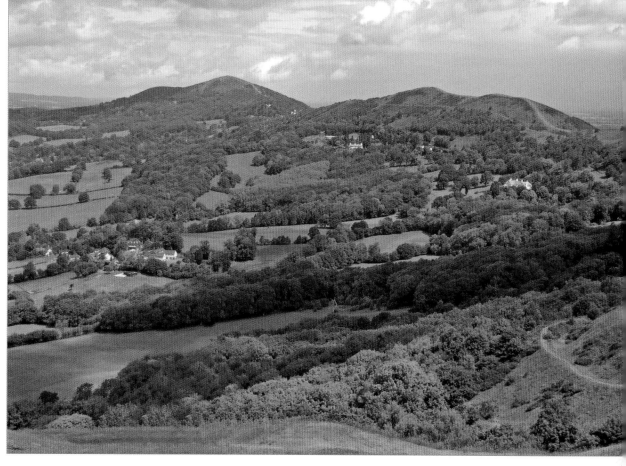

Roger was a devoted admirer of Sir Edward's Elgar's music and frequently visited the inspiration for so much of it – the Malvern Hills. Here are some of the oldest and hardest rocks in the British Isles, thrust up 680 million years ago in the middle of a lowland plain. Roger was hugely impressed with their abruptness. In 1976 he wrote, *Of all the hills in these islands the Malverns come nearest to being Himalayan in one respect: no other true range rises so suddenly and steeply from the surrounding lowland.* This view was taken with a digital camera on his last visit in May 2011 and is the view northwards from Herefordshire Beacon, 1,109ft, toward the highest summit in the range – Worcestershire Beacon, 1,395ft, and described by him as *this supreme crow's nest of lowland England.* Wooded slopes and conical peaks are the characteristics of this 'mountain' range in the middle of rural Britain.

Herefordshire Beacon (*opposite*) viewed from the pasture lands on the western side of the hills, a summit encircled with distinctive Iron Age earthwork defences, and a popular destination for crowds of walkers on fine weekends. Needless to say, Roger avoided the Malvern honeypots at busy times, preferring to wander along their slopes and through their woods instead. Here he's encountered some young cattle near Colwall, two of which are Highland cattle, a breed he often came across in north-west Scotland, but rarely in a Herefordshire field!

IN FIELD AND FOREST

It's October 1990 and Roger is probably on his way home from a day in the Peak District. To get to his house he has to cross Leash Fen, a wild and open area of badly-drained pasture west of Chesterfield. The clouds would part, his car would screech to a halt, and he'd jump out to catch this split second shot of cow silhouettes against a menacing sky split by shafts of sunlight. A 'grab' shot if ever there was one!

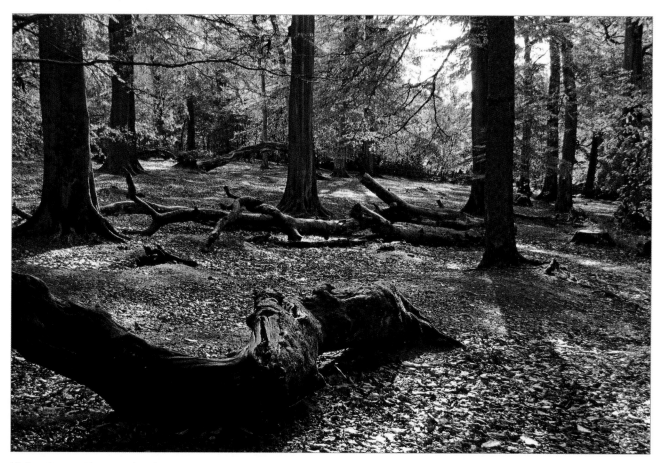

His last *Country Diary* entry for *The Guardian* was on 7th November 2011 when he wrote about Alderley Edge, what he called *this dramatic Cheshire belvedere*. He took this shot on the Edge with a digital camera in October 2011, one of the last images he ever captured, but he's clearly lost none of his ability to compose an eye-catching scene. These woodlands did not exist before the late 18th century, *so now we have the bonus of delightful woods hanging on the steep north-eastern flanks and right along the top – woods that also contain Spanish chestnut that now adds autumn gold to complement the last yellow leaves of silver birch.*

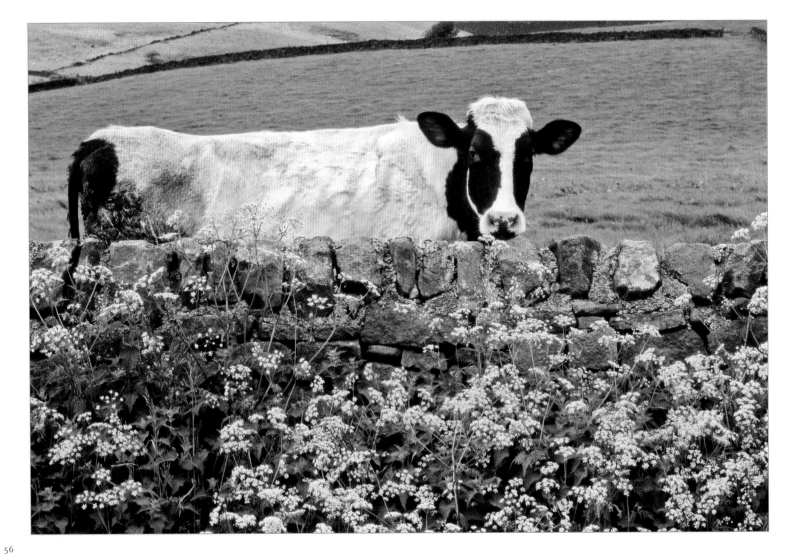

Because his walks were so often off the well-trodden paths taken by the throngs of visitors, chance encounters with beasts in their fields were common, so he has quite a collection of evocative 'animals looking over walls' photographs. Some were startled and took flight, but others would stand and gaze curiously and even 'pose' for what might be a welcome distraction.

Opposite; A cow and cow parsley at Nether Booth in the Vale of Edale in May 1997

It's almost as though these three Whitwell Moor ponies encountered in April 1994 were used to visitors and would automatically arrange themselves in an appropriate order for a striking photograph.

The remnants of a morning thunderstorm in Barlow Vale in July 1988 are just clearing away, allowing this group of heifers to come out of hiding and peer over the wall at Roger. He was no doubt passing on his bicycle or motorbike to help out on the farm he once worked on in Unthank in the same valley.

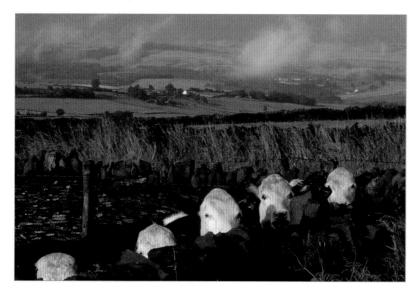

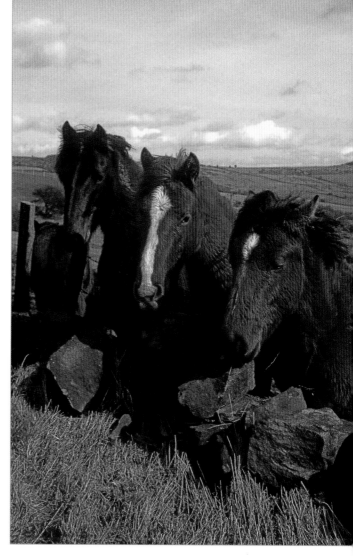

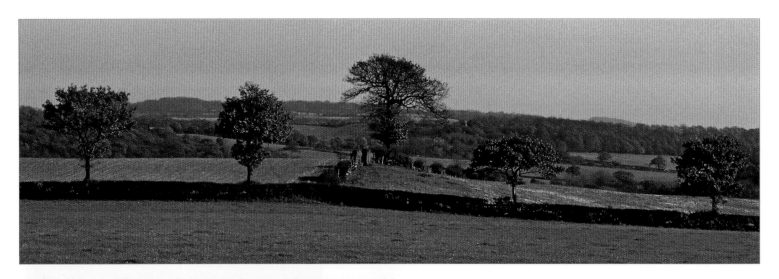

A shot composed with meticulous care to ensure the symmetry of composition of the five hedgerow trees just acquiring their autumn tints in November 1976 in the Cordwell Valley, near Chesterfield.

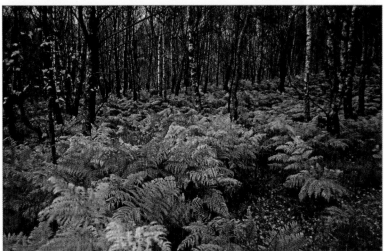

It isn't just the trees that turn golden in the autumn, the ferns in this silver birch wood at Padley Gorge, part of the Longshaw Estate in the Peak District, also acquire their fronds of gold at the same time, in this case November 1990. This is one of the finest remaining examples of the birch woodland once so common on the edges and valley sides of the Dark Peak. It's also a habitat for many rare species of plants and animals and has therefore been designated an SSSI.

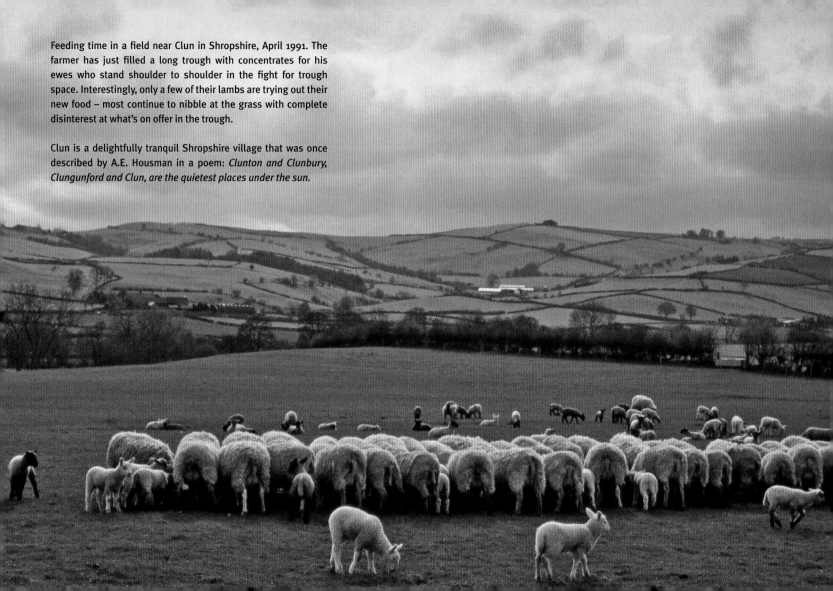

Feeding time in a field near Clun in Shropshire, April 1991. The farmer has just filled a long trough with concentrates for his ewes who stand shoulder to shoulder in the fight for trough space. Interestingly, only a few of their lambs are trying out their new food – most continue to nibble at the grass with complete disinterest at what's on offer in the trough.

Clun is a delightfully tranquil Shropshire village that was once described by A.E. Housman in a poem: *Clunton and Clunbury, Clungunford and Clun, are the quietest places under the sun.*

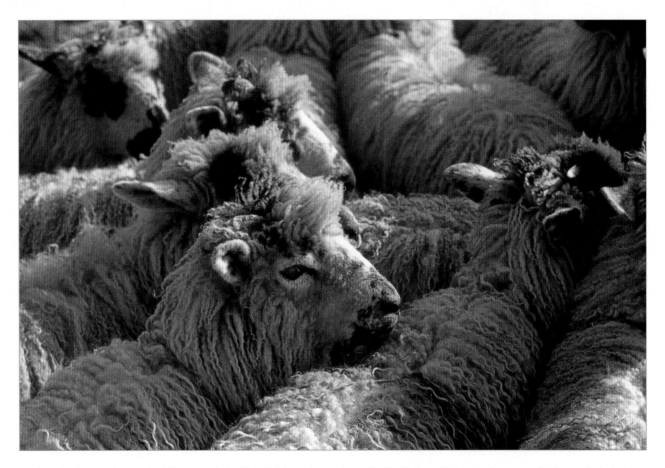

Masham lambs at a sheep sale at Biggin in Derbyshire, October 1984. Although there are ten sheep in the picture, we can see only one eye. A real eye-catching image!

Opposite; The Barlow Vale hounds being exercised through the bracken of the Cordwell Valley in January 1977, led by the Master in his striking red jacket. They're about to enter Smeekley Wood, although large areas around it have been smothered by rhododendron bushes, the green mounds in this picture become a riot of reds and pinks in May and June.

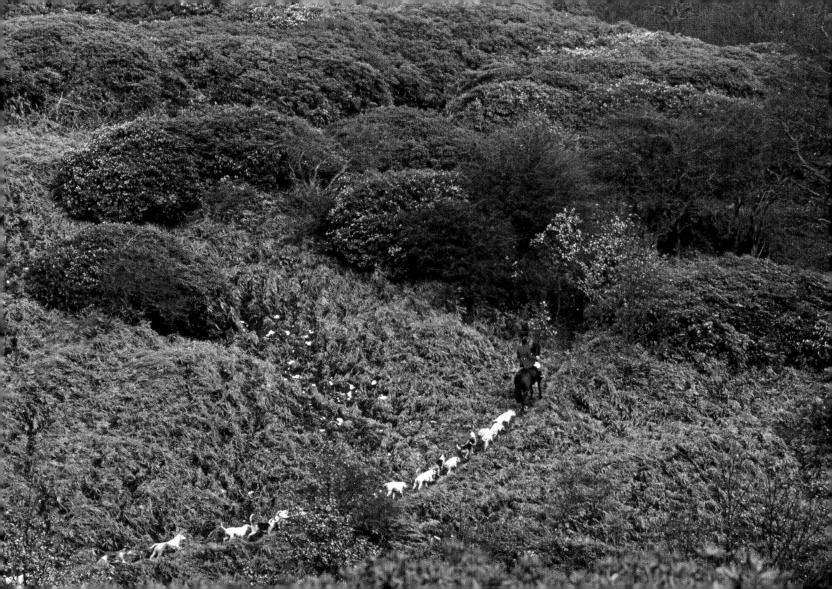

Poppies are not an agricultural crop in this country, but they can sometimes be a persistent weed in agricultural fields. They are a problem for the farmer, but a delight for the photographer in high summer. Roger found these poppies colonising a field near to his home town of Dronfield in July 1987, and what a colourful spectacle they make.

Much commoner these days are the vibrant yellow fields of oil seed rape that cover our countryside. This one is near his home in Old Brampton in May 1986.

Always on the lookout for something quirky or traditional in the countryside, this is a typical example – a Swaledale gate in July 1969 (he had a collection of stile pictures) whose hinges have been fashioned from what look like the soles of a pair of wellingtons by an enterprising farmer.

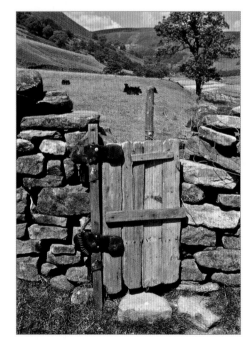

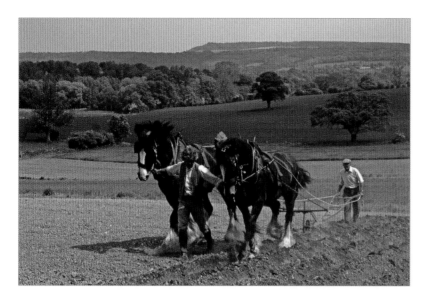

The Acton Scott Historic Working Farm in Shropshire was sure to get a visit whenever he was in the county. It was a reminder of the sights, sounds and practices of the farming he would have recognised from his childhood. He always took his camera with him and always returned with some memorable images.

Demonstrations use authentic equipment, techniques and horsepower. Here a couple of shires and their handler, in traditional dress, pull a single furrow plough (probably a Ransomes by the colour) in May 1992.

Another image from the quirky/amusing collection taken at the Acton Scott Farm in April 1996. Roger used to caption slides like this to catch the eye of the editors. This one, of a huge shire turning to watch the ploughman who is holding an oil can and studying its hooves and legs, was captioned 'Oiling Up!'

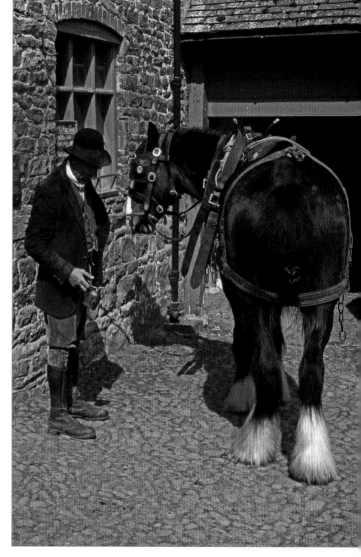

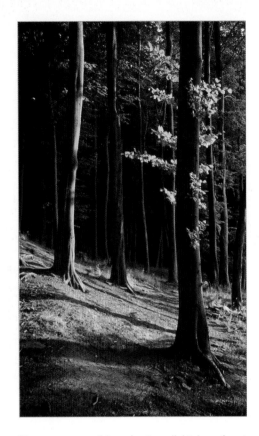

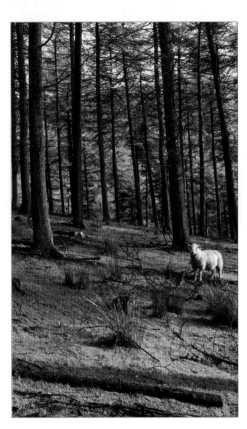

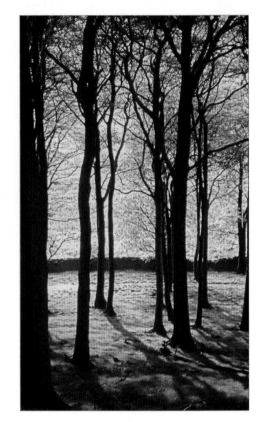

There was something about sunlight in a forest or through the leaves of a tree that clearly held a fascination for Roger and, I must admit, for me as well. There must be several hundred variations of this theme in his slide collection of which these three are but a tiny sample.

'Evening Light in Linacre Wood July 1989' (*left*) was just a five minute walk from his house.

'Solitary Ewe in Larch Wood November 1994' (*above*) – larch is the only coniferous tree whose needles turn golden and are dropped – a coniferous deciduous tree.

'Afternoon Sun in Smeekley Wood July 1975'

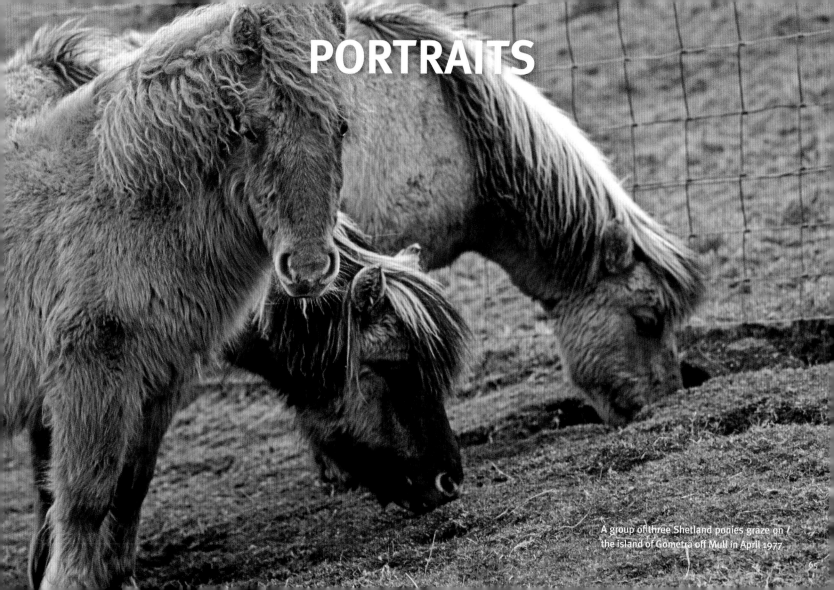

PORTRAITS

A group of three Shetland ponies graze on the island of Gometra off Mull in April 1977

I've interpreted the term portrait quite liberally for these images which are a study of either people or animals. Roger probably has more portraits of animals than people in his collection, because he encountered more animals posing in an interesting way than people! Like this Ayrshire cow for instance, standing outside a croft at Keils on the Hebridean island of Jura in August 1964. Behind her the barns have been thatched, and even the haystack has been thatched to keep the rain out on this damp island.

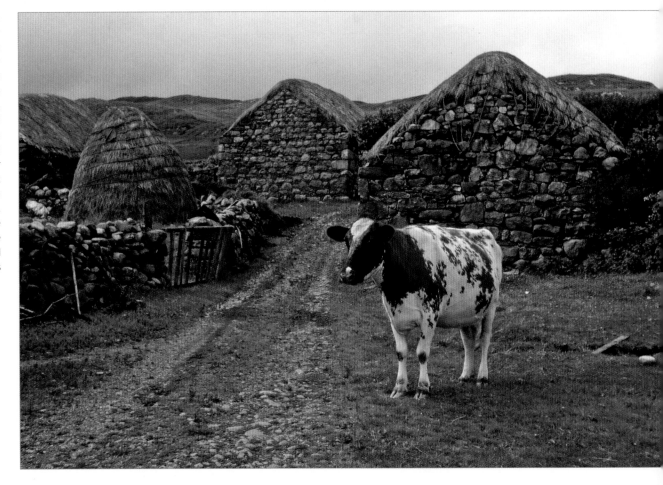

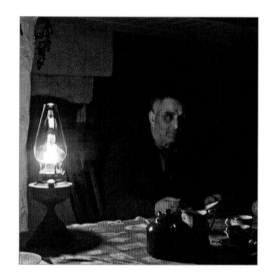

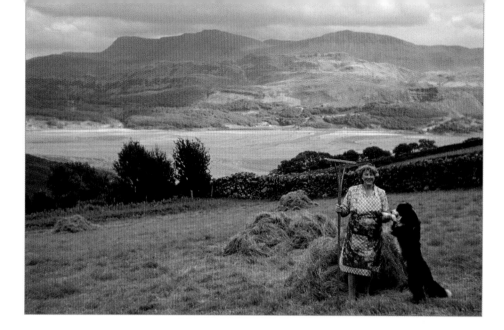

Above; Roger's Uncle Hughie and Aunty Mary ran a small mixed farm called Llwyn-onn Bach above the Mawddach Estuary in mid-Wales from 1949–84. It was a place of summer pilgrimage for him as a boy when his mother visited her sister and his days were spent helping on the farm, walking in the local hills or sailing on a yacht his father hired.

Above left; Mains electricity didn't arrive until the 1960s so the portrait of Uncle Hughie eating a meal inside Llwyn-onn had to be taken by oil lamp. Auntie Mary and her sheepdog Rough in August 1959 while haymaking by hand in one of their fields above the Mawddach with Cadair Idris beyond.

A similar view in July 1976 but this time the dog's name is unknown.

Here are a few more interesting animal portraits that will make you smile.

A West Highland Terrier has found an opening in what looks like a barn wall big enough to get his head through, from where he can observe (and bark at!) people passing by. June 1976.

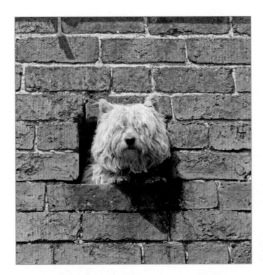

Roger called this one 'Dignity & Impudence' in March 1993 when he encountered the Shire horse and its Shetland pony companion on Whitwell Moor near Stocksbridge, South Yorkshire.

This is a rare example of a colour slide that doesn't have the exact location written on it. The date is November 1980, so by cross-referencing with his other slides I know that this is probably on the island of Jura on the west coast of Scotland. It's another example of an unexpected encounter with animals, either wild or farm, while in the countryside. The little calf on the left-hand side adds a nice touch to the family group of completely unconcerned Highland cattle.

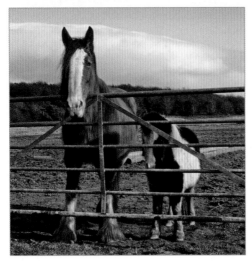

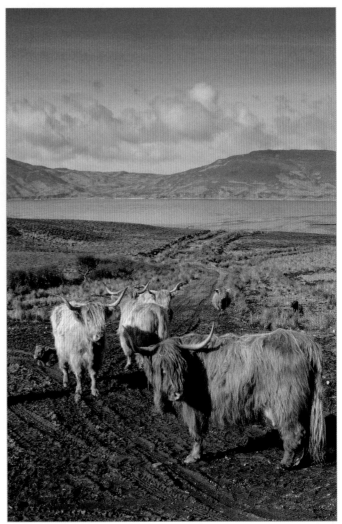

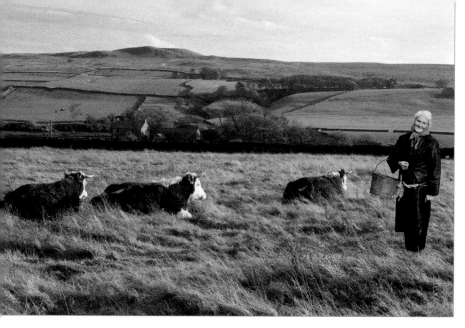

These are the only two black and white pictures taken by Roger that I've included in this volume, because they demonstrate how he was able to make his human subjects feel instantly relaxed and at ease with him. If you don't recognise the subject of these shots it's Hannah Hauxwell, the lady who single-handedly ran a farm with no mains water or electricity in the Yorkshire (now Durham) Dales for 28 years, carrying pails of water for her animals from a stream and bales of hay on her back. A Yorkshire Television programme in 1973 changed her life and she became something of a reluctant celebrity. Roger visited her at Low Birk Hatt Farm in October 1977, they chatted about her life and things countryfolk talk about and got on really well. You can tell there was a rapport from these wonderful portraits of Hannah, her animals and sheepdog, Chip. She retired to a nearby village in 1988 – a remarkable woman.

A keen angler trying his luck for trout or salmon in the River Lledr at Betws-y-Coed in July 1979.

The oldest shop in Dronfield with Frank Fisher, local butcher, sharpening his knife in the doorway on High Street. When this picture was taken in May 2002, you'll note they had been established 200 years. Today the shop boasts that it was 'Established in the reign of Queen Anne 1702'.

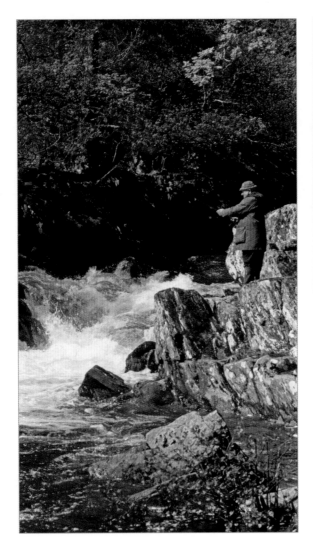

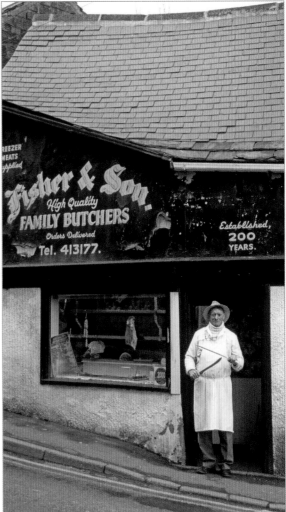

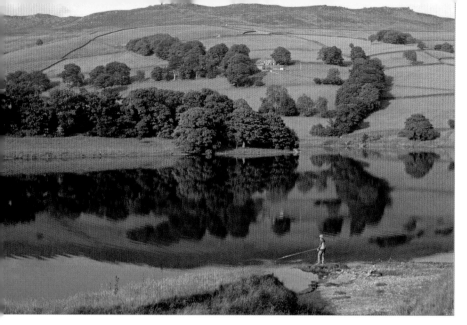

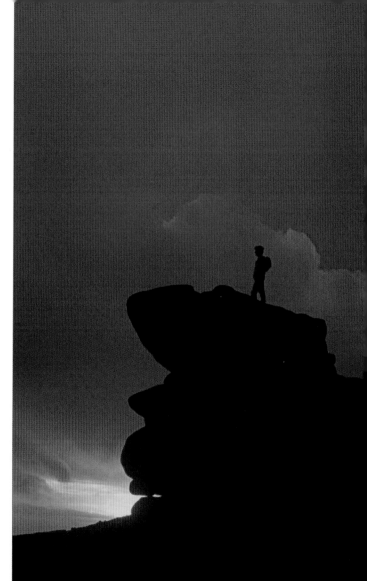

Almost a perfect reflection in the water of Ladybower Reservoir in September 1981 as another lone angler tries his luck, but in much more tranquil waters than the one opposite. Up above is Derwent Edge with the profile of the Salt Cellar immediately obvious. Roger once hinted in a 2008 *Country Diary* that the appeal of these giant bodies of water was not to everyone's taste: *Some think the many reservoirs of the south Pennines add beauty to otherwise dreary moor-tops and twisting gritstone dales; it's a matter of opinion.*

It's a silhouette, but a portrait nevertheless from November 1988. The sun is setting in a dramatic fashion behind Noe Stool, one of the many gritstone outcrops that mark the western edge of the Kinder Scout plateau.

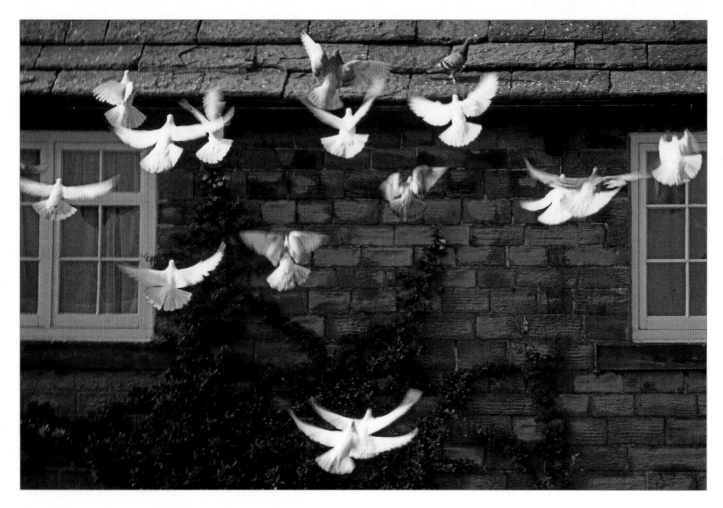

The roof of Roger's house in Old Brampton was home to a flock of doves and pigeons that regularly took off, did a couple of circuits, and landed again. By standing patiently in front of his house he caught this splendid picture of their return in July 1971.

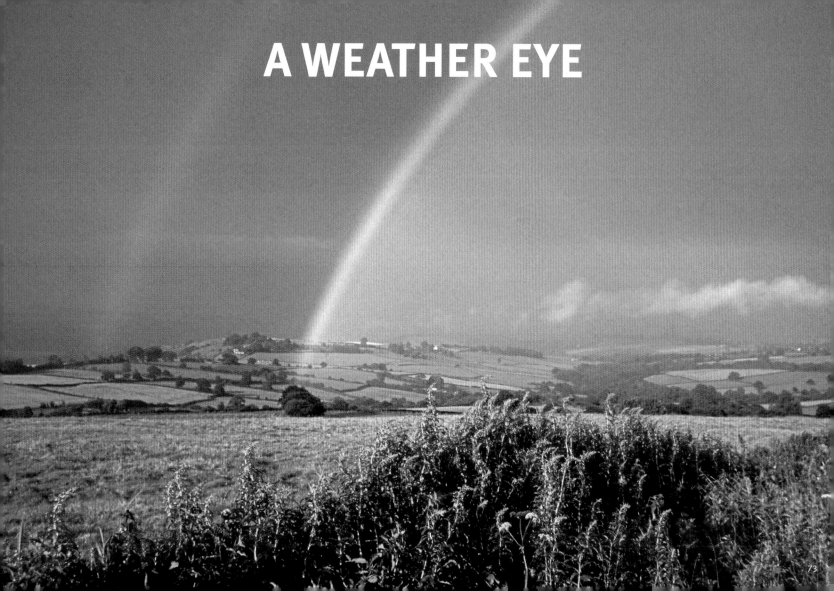

A WEATHER EYE

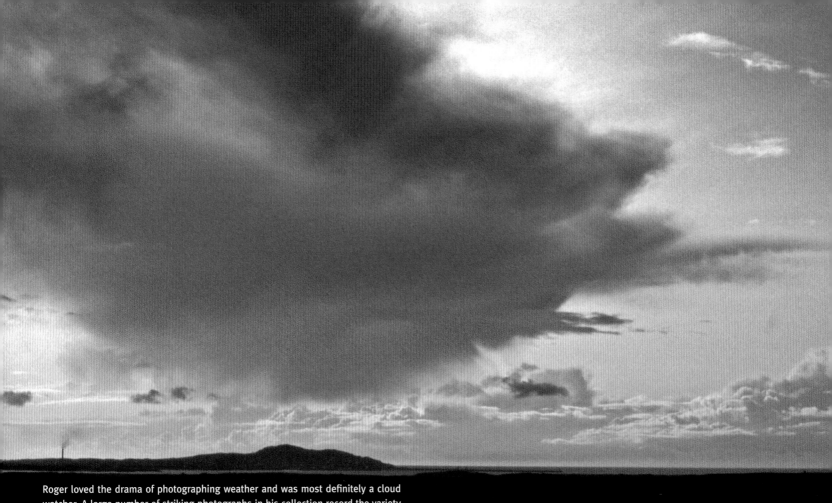

Roger loved the drama of photographing weather and was most definitely a cloud watcher. A large number of striking photographs in his collection record the variety of shape and colour of clouds he encountered. This one is of a menacing cloud above Holyhead Mountain on Anglesey, taken from a vantage point in the middle of the island in September 1992. It looks like a heavy shower is on the way for someone

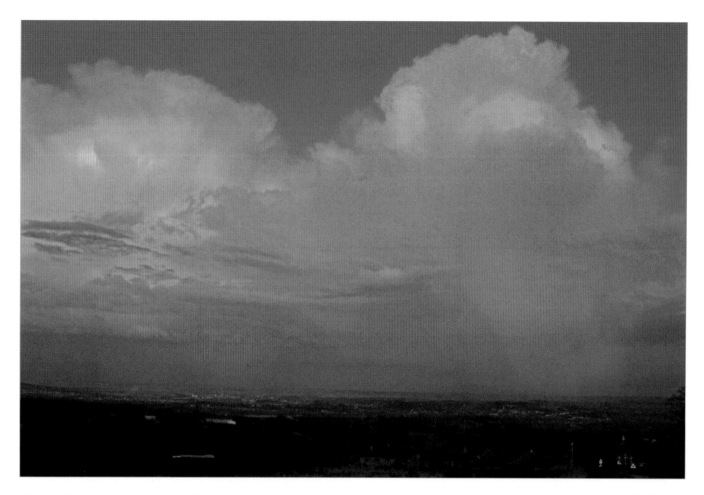

Whenever he came across scenes like this, the car would screech to a halt and the cameras would be out – and who could blame him. This drama was unfolding above Chesterfield in April 2000 and you can just see its twisted spire picked out by a shaft of sunlight to the left of centre. The location is the delightfully-named Pudding Pie Hill which was the closest the Peak District National Park boundary got to his house at Old Brampton.

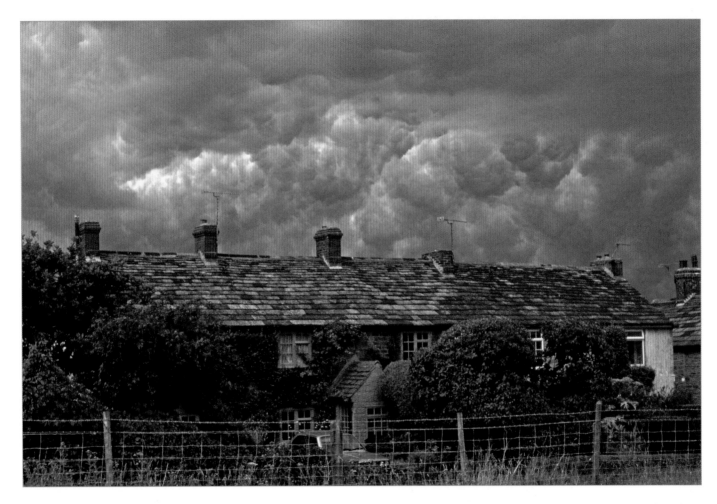

Now these really are angry clouds gathering above his house in August 1986. Boiling would perhaps be an accurate description if we could see their movement, and it won't be long before the drama unfolds and the thunderstorm breaks.

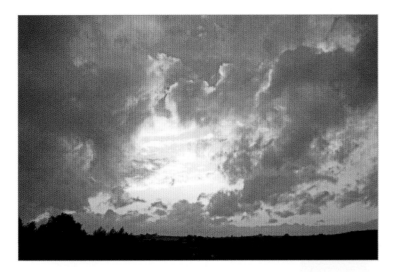

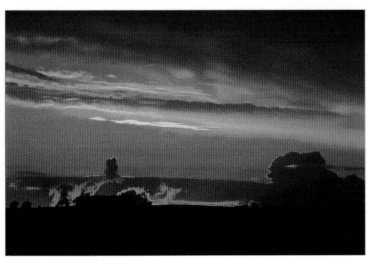

All the images on this page and the one opposite were taken from his garden or a short distance away.

A glorious sunset (*below*) in July 1990 highlighting the interesting cat and mouse weather vane he had attached to the self-built folly at the bottom of his garden.

By hopping over his garden wall (*below left*) and into the field next door he caught what appears to be a fire on the horizon in July 1979, but look carefully and you'll see it's not smoke but clouds backlit by a setting sun.

This one (*left*) could almost have been painted by John Constable himself – master of the cloudscape. In 2008 Roger wrote, *John Constable's skies are so believable because he spent a lifetime observing and recording them. He really began a tradition of East Anglian artists who knew how to apply the paint to such realistic effect.* It isn't a painting but a photograph from September 1970.

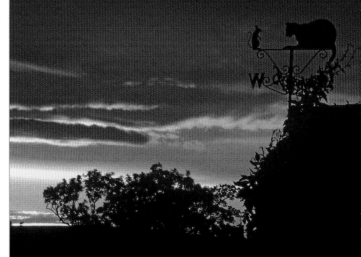

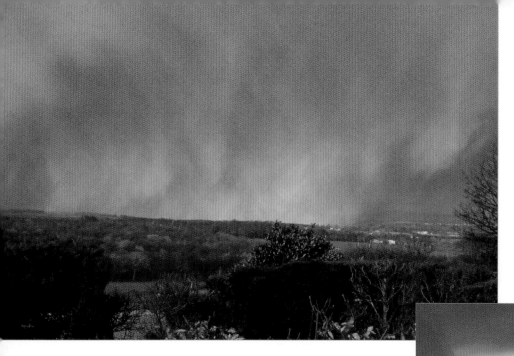

Looking northwards across the Linacre Valley at a rapidly moving snowstorm in March 1993, it looks as though it's going to give Old Brampton a miss and hit Chesterfield instead. What we can't experience are the gusts of wind and noise that would be accompanying this spectacle.

A very rare sight indeed, not just for Old Brampton but for the whole United Kingdom. These are nacreous or mother-of-pearl clouds that form at altitudes of between 12 and 15 miles in temperatures below -80°C, but are only seen around sunrise and sunset when their colours stand out against the darkened sky. These clouds appeared over Roger's house on 16th February 1996, and there have only been another four sightings in the UK since then (up to December 2012.) Because of their high altitude and the curvature of the Earth, these clouds reflect sunlight from below the horizon which causes their bright translucent colours. They have been mistaken for UFOs in the past and are considered to be one of the most striking atmospheric phenomena.

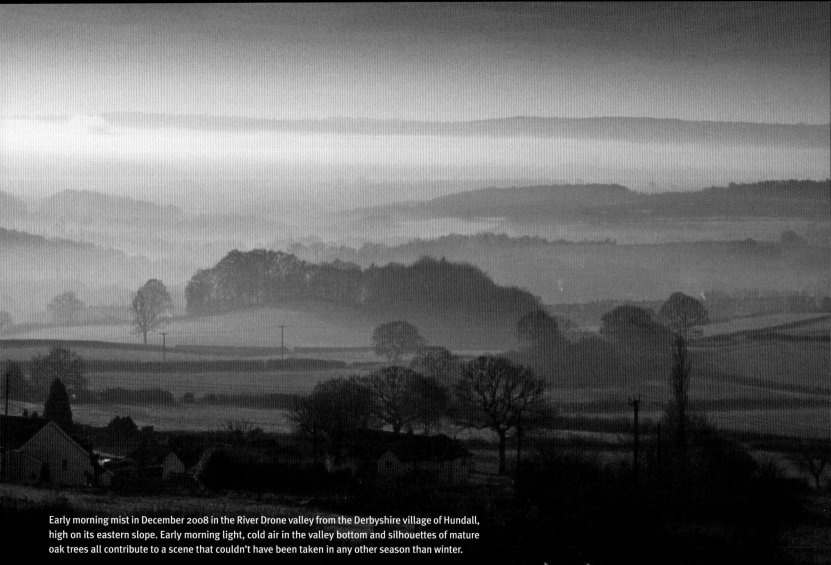

Early morning mist in December 2008 in the River Drone valley from the Derbyshire village of Hundall, high on its eastern slope. Early morning light, cold air in the valley bottom and silhouettes of mature oak trees all contribute to a scene that couldn't have been taken in any other season than winter.

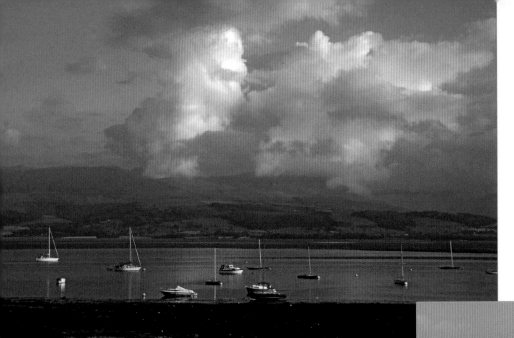

Whenever Roger captioned a photo like this, or wrote about his experiences of the day in one of his *Country Diary* pieces, he would inevitably refer to these clouds as towering. They certainly are, and the anvil-shaped top means they're probably cumulonimbus rather than just plain cumulus. These produce spectacular thunderstorms under the right conditions, and it looks as though the hills of Snowdonia are receiving exactly that, while the Menai Straits and the boats anchored off Beaumaris in September 1992 are bathed in pleasant evening sunshine.

This really is a storm, without the thunder, just wind. It was a storm Force 8 as I recall, and it prevented our ferry, the *Claymore*, reaching Tiree on time in April 1969 on its return to Oban from South Uist. Instead of 6 o'clock in the morning, it turned up at 5 o'clock in the evening. There was nothing much to do at Hynish on Tiree except kill time by standing on the shoreline and lean into the wind, hoping it might lessen a bit by the time the *Claymore* arrived. It didn't, and the journey from Tiree until we got to Tobermory in the Sound of Mull was what you might call uncomfortable!

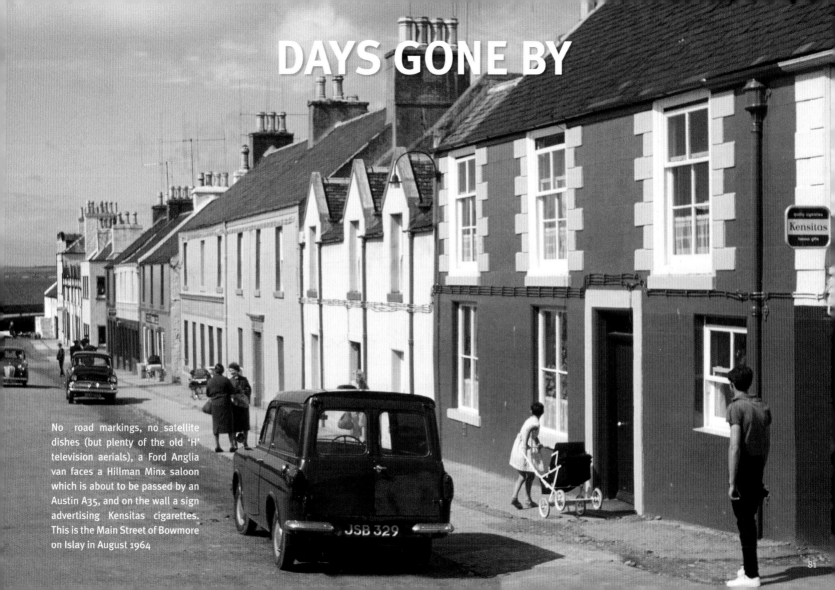

DAYS GONE BY

No road markings, no satellite dishes (but plenty of the old 'H' television aerials), a Ford Anglia van faces a Hillman Minx saloon which is about to be passed by an Austin A35, and on the wall a sign advertising Kensitas cigarettes. This is the Main Street of Bowmore on Islay in August 1964

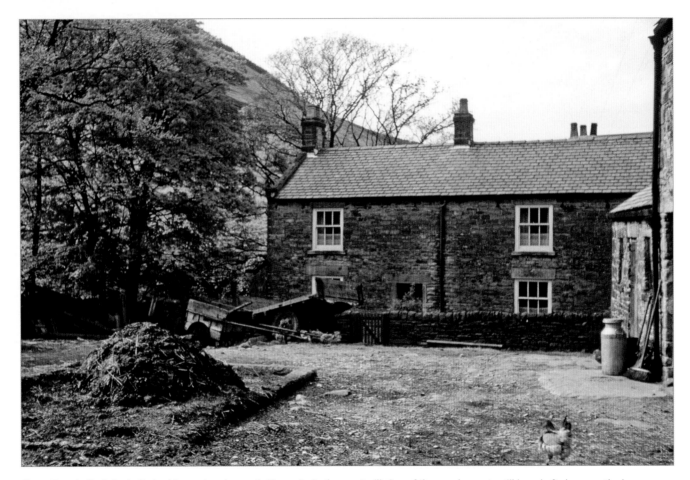

Alport Farm in Dark Peak, Derbyshire captured on 14th May 1960 in the days when farmers could make a living off a relatively small acreage of poor land. The dung from the animals was piled in the middle of the un-concreted farmyard, in which hens had free range to scratch and forage at will. One of the wooden carts still has shafts because the horsepower needed to move it would still have come from . . . a horse! A milk churn stands by the entrance to what is probably the milking parlour. Very much a scene from yesterday's farming.

In April 1961 on the island of Harris in the Outer Hebrides there was no such thing as a tumble drier or a rotary washing line. Washing had to be pegged onto a line slung between two stout posts, and if that wasn't possible then it was attached to anything that wouldn't blow away in the fearsome wind that could sweep over Harris. On this croft the washing has been pegged onto the boundary fence – the same fence that keeps the sheep from the haystack also drying in the wind. Life could indeed be hard for remote island communities such as this.

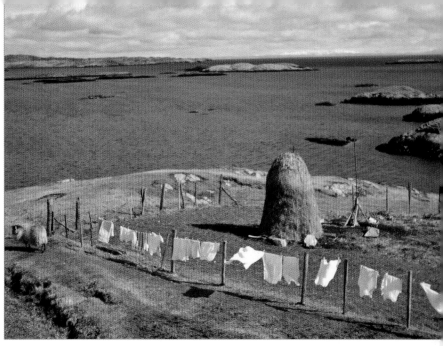

Making hay in the Yorkshire Dales in July 1969 involved the whole family. The farmer has cut the hay with a tractor but raking it into rows involves the manual labour of his wife and daughter seen here hard at work in a Swaledale field.

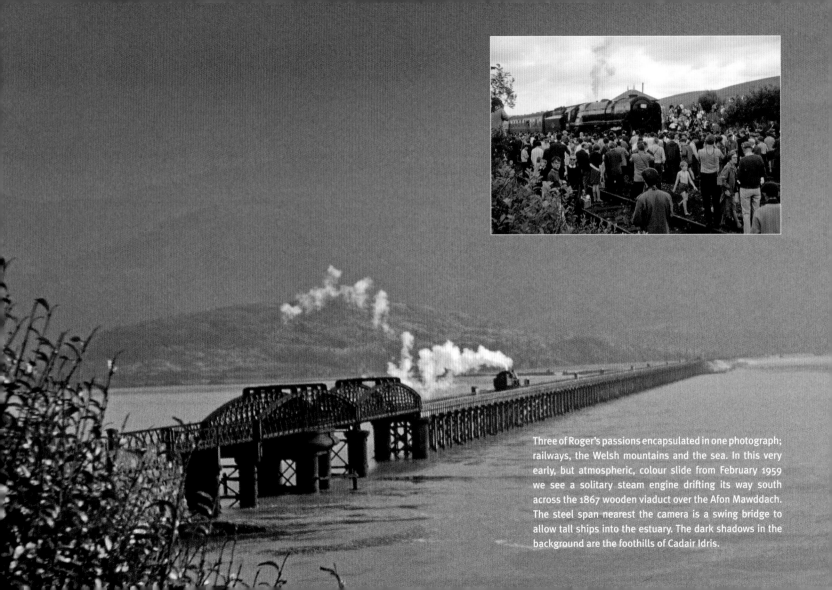

Three of Roger's passions encapsulated in one photograph; railways, the Welsh mountains and the sea. In this very early, but atmospheric, colour slide from February 1959 we see a solitary steam engine drifting its way south across the 1867 wooden viaduct over the Afon Mawddach. The steel span nearest the camera is a swing bridge to allow tall ships into the estuary. The dark shadows in the background are the foothills of Cadair Idris.

Railways had been a passion of Roger's since boyhood. One of his favourite lines was the famous Settle-Carlisle route through the Yorkshire Dales which he visited whenever he was close.

A day gone by (*opposite inset*) that was truly memorable for a huge chunk of the population. British Rail's very last train hauled by a steam locomotive ran on 10th August 1968 from Liverpool to Carlisle and back over the Settle–Carlisle route. Locomotive 70013 *Oliver Cromwell* stopped for a photo opportunity at the 1,168ft summit of the line outside the signal box at Ais Gill (just visible behind the engine) where it was engulfed by a crowd of hundreds who blocked the road with their cars and blocked a main England–Scotland rail route with their bodies. But it was a good natured gathering; when a whistle was blown the crowd parted like the Red Sea, *Oliver Cromwell* continued its journey into history, and the disciples went home.

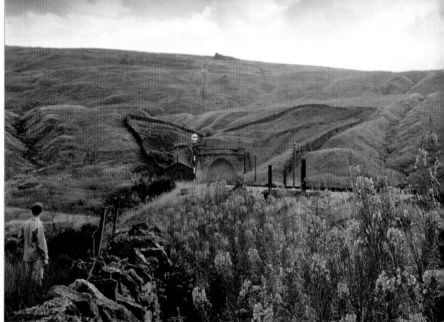

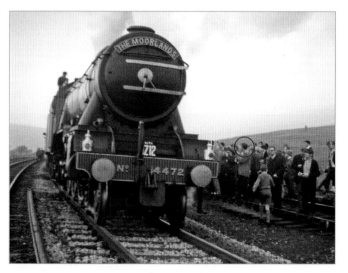

A poignant image in many ways, Roger called this 'The Last Smoke'. It refers to the wisps of blue smoke spilling from the mouth of Blea Moor tunnel (2,629 yards) after British Rail's last steam train had just passed on its return trip south to Liverpool. In *Portrait of the Pennines* he recalls that, *The bank on which we sat and chatted with fellow enthusiasts was pink with heather flowers and across the line was a colony of rosebay willow herb in full bloom.* There were now no more British Rail steam-hauled trains on the network, drawing to a close over 140 years of unbroken service.

Still on the Settle–Carlisle, this is the unmistakable 4472 Flying Scotsman locomotive. Bought from British Rail and saved from the scrapyard by Sir Alan Pegler, it was given special dispensation to run on British Rail metals for several years after the events of August 1968. It's stopped for a photo opportunity with The Moorlands Railtour at Blea Moor, at the other end of the tunnel above. Roger organised a school trip for a group of us in October 1969, and this is my photo of the events of Blea Moor. It was only many years later that I realised Roger was actually in this photo – he's circled in red with camera in hand. (Author)

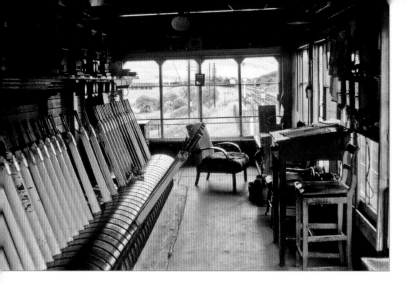

A rare sight on any railway line in Britain these days, and soon to be extinct. An old mechanical signal box in use was a wondrous place. There were huge coloured metal levers that required considerable brawn to change the points and signals, telegraph systems to communicate with the boxes on either side, worked by a series of bell codes, and, inevitably, a coal-fired stove to keep the signalman warm in winter. This is Garsdale signal box (formerly Hawes Junction) on the Settle–Carlisle line in July 1969, the very box from where, on Christmas Eve 1910, the signalman made a fatal error that wrecked an express train and killed 12 passengers. The high chair and desk are for recording every train movement in the log.

The Elvaston Country Show, Derbyshire in 1963. A trio of ladies, all with their best hats on, perch on folding chairs eating their lunch from one of the new, air-tight plastic lunch boxes with resealable lids that were introduced into the UK three years earlier. They are surrounded by a fascinating collection of vintage livestock vehicles of the day.

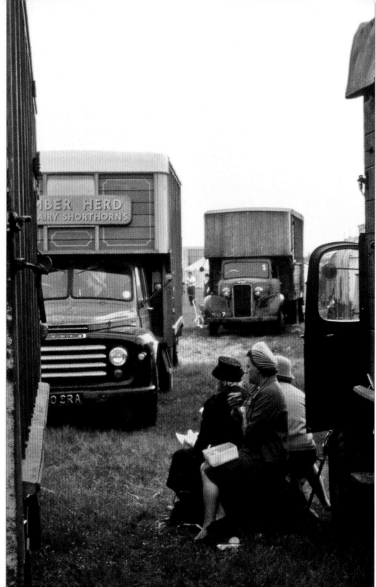

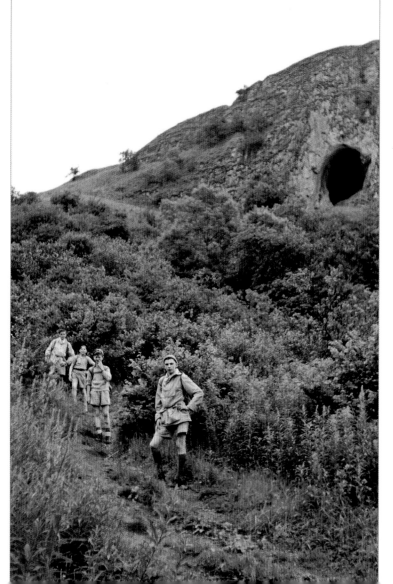

Four of his pupils out on a ramble with Roger in the Manifold Valley on 3rd July 1959 below the unmistakable mouth of Thor's Cave. It's interesting to see how khaki shorts and knee-length socks are very much *de rigueur* for outdoor pursuits over 50 years ago. The high-vis, fleece-lined, water repellent, ultra-light performance mountain-wear has yet to make its debut!

Butler and Wright hard at work in May 1959, perhaps digging a trench for potatoes, at Gosforth School in Dronfield. After becoming a teacher this was Roger's second job and eight years before his return to his old grammar school in the town. This would be a rural studies lesson where pupils were instructed in agriculture, horticulture and environmental education as part of the school curriculum. Most rural secondary schools had an area of the school grounds specifically for the growing of crops or rearing animals, and many had a substantial purpose-built glasshouse and tool store like this one. Nowadays finding a school that teaches just one of these subjects is as rare as hen's teeth!

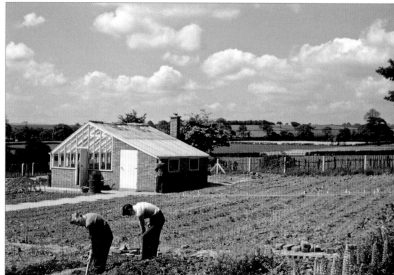

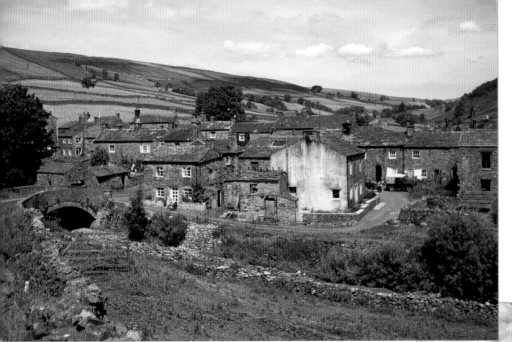

This view of the *small and unspoilt* village of Thwaite, and the bridge over Thwaite Beck in Swaledale, could have been taken at any time in the previous 100 years. *In Portrait of the Pennines* (1969) Roger describes how, *the place gives the impression of a defensive settlement, not against the violence of Man but more against the violence of Nature on nights of high wind and blizzard conditions.* If you look carefully, there are only a few television aerials and a Land Rover and grey Fergie tractor in the yard on the right that give any clue to its actual date of July 1969. There's nothing else in this view to date it by – and it doesn't look much different today!

The range of farm machinery Roger encountered in his 50+ years' relationship with working farms would have been enormous. This early Massey Ferguson combine harvester would have been state-of-the-art when it was built sometime in the 1960s, but looks woefully dated today with its tiny reel and lack of a safety cab. It doesn't even have a mechanism to empty the grain tank into a trailer so it needed two men to operate it, the second man filled hessian sacks with the grain for transport back to the farm. It was taken in the Cordwell Valley near Chesterfield, and the date? September 1970!

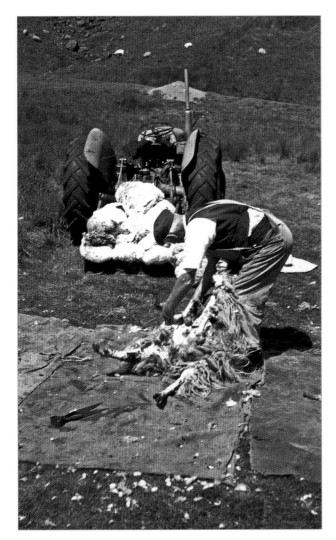

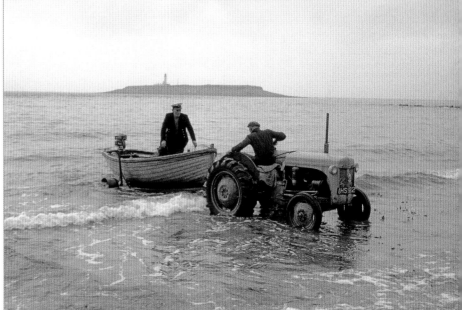

The ubiquitous Ferguson TE20 grey tractor, the Fergie, was a mainstay of British agriculture. Over a million of these sturdy little workhorses were produced in the UK and USA between 1946–56, but they were still a common sight on British farms and elsewhere throughout the 1960s and always merited a photo wherever he found one.

Here it is being used to launch the lighthouse relief boat at Kildonan, Arran to take keepers and provisions to Pladda Lighthouse beyond, April 1963.

Shearing sheep by hand at Buttertubs in Swaledale, July 1969.

THE CHANGING SEASONS

Spring is the time when the new leaf growth makes its welcome reappearance, usually in magnificent shades of lime green. In May 2010 the mature trees surrounding Offerton Hall in the Hope Valley already have theirs, and all the way up the valley towards Bamford village and Derwent Dale beyond are a hundred shades of green as each new species comes into leaf.

We've already seen views of Smeekley Woods in the Cordwell Valley, such as the Barlow Vale huntsman with his hounds amongst the rhododendron bushes. For most of the year they are just invasive evergreen mounds of *Rhododendron ponticum* foliage, but in May and June they are smothered in flower and make a truly dramatic picture that lasts only a couple of weeks. Here are a couple of views of Smeekley Woods in June 1974, with the bushes in full bloom, and just for good measure Roger has included a broken-down wall in the foreground.

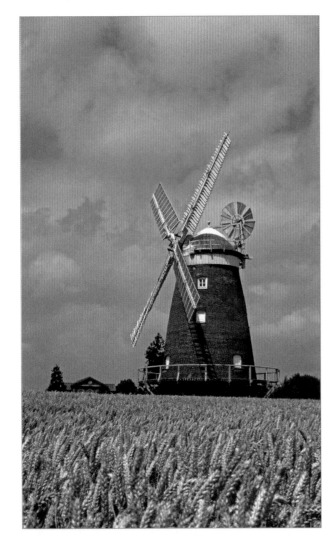

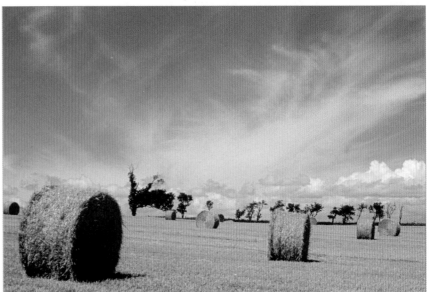

It's high summer in the English countryside and time for the harvest to be gathered.

John Webb's windmill in Thaxted, Essex dates from 1804 and was restored in 2005 – seven years after this picture was taken in July 1998. It was constructed to mill the local wheat grown to satisfy the increasing demand for flour in Essex and London.

The harvest has been cut (*above*) and the remaining straw baled into the round bales that always seem to make an interesting picture when still in the fields. The field in this case is near Chatton, Northumberland in July 1989.

Autumn was his, and my, favourite season (*opposite*). The dramatic, colourful changes to the landscape never fail to surprise and enthral. Here, a lady walks her dog through the golden surrounds of Harper Lees in the Derwent Valley near Hathersage in November 1990.

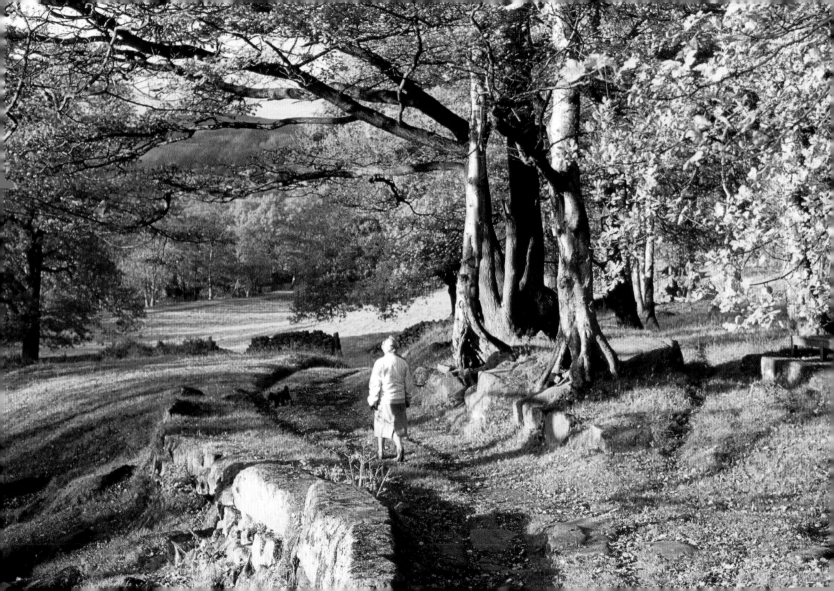

A magnificent autumn portrait from October 1988 of the golden hues displayed by bracken fronds in Rose Wood above Millthorpe in the Cordwell Valley. Here we see the full range of colours from healthy green through to the autumnal yellows and browns. The fact that Roger has caught it as a shaft of sunlight lit up the fronds while the remainder of the wood is in darkness makes this image a little special.

The plantation of larches in front of the Derwent Dam wall have just about dropped all their autumn colour, which fortuitously allows a good view of the water spilling over the dam itself in November 2000. Completed in 1914, the wall holds back over 9 million cubic feet of water, and in times of high rainfall its overflow of the dam wall is a popular tourist attraction. In 1943 it was also the dam used by the 617 Dambusters Squadron to practise their daring low-level raids on German dams because of their similarity in design.

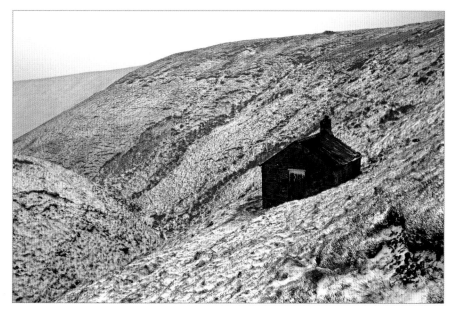

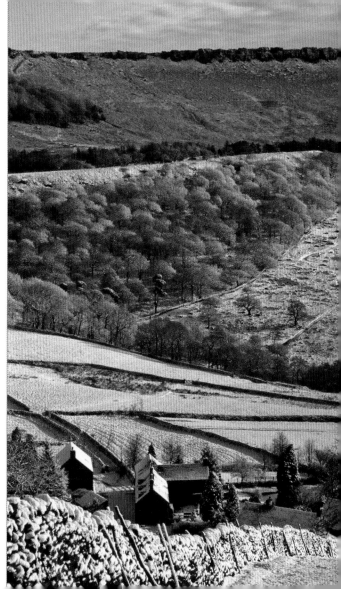

It's January 1970 and this looks like an early black and white image, but it's not. Look carefully and you'll see shades of brown in this striking image of a *finely situated shooting cabin at the 'wild end' of the long traverse down Oyster Clough.* This is a popular route onto Bleaklow's southern slopes above the Snake Inn and the cabin is perched on a ledge gouged out of the valley side. It's a bleak and spartan refuge for those who shoot grouse on these moors from 12th August onwards, but a welcome route-marker for those unlucky enough to find themselves on Bleaklow when the mist descends.

Thirty-one years on, here's another atmospheric winter scene of Stanage Edge in December 2001 from above the settlement called Green's House. The stream in the bottom of the valley is called Hood Brook. In a *Country Diary* of 2002 he explained that, *This small, steep tributary of the Derwent seems to have earned its name from Ordnance surveyors in 1840, probably out of a romantic association with Robin Hood, who is linked with a section of Stanage Edge overlooking this valley.* The light and shade, sunlight and shadow, woodland treetops with a dusting of snow, and the stone wall lead your eye into the picture, making it a real stunner.

It is hoped that this volume will be followed by

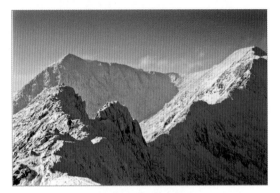

A Mountain Camera

An Island Camera

so keep checking our website
www.whittlespublishing.com

By the same author

Rock Lighthouses of Britain

ISBN 978-184995-137-1

'... what a book it is, with new and revised text, information, layout and superb illustrations ... This is truly a feast of good reading for casual reader and serious pharologist alike. ... a rollicking good book, a copy of which really ought to be on everyone's sagging bookshelf. Buy and enjoy.'

Postcards from the Edge

ISBN 978-1904445-59-3

'... a delightful and charming book. ... the great delight of this publication is the visual attractiveness of the postcards. ... It is lavishly illustrated and the quality of the reproduction is high. It is packed with interesting historical information ad will have a very wide appeal.'